500

Composition

Hints, Tips, and Techniques

for Photographers

RotoVision

A RotoVision Book
Published and distributed by RotoVision SA
Route Suisse 9, CH-1295 Mies
Switzerland

RotoVision SA, Sales & Editorial Office
Sheridan House, 114 Western Road
Hove BN3 1DD, UK

Tel: +44 (0)1273 72 72 68
Fax: +44 (0)1273 72 72 69
Email: sales@rotovision.com
Web: www.rotovision.com

10 9 8 7 6 5 4 3 2 1

ISBN: 978-2-940378-34-0

Designed by Fineline Studios
Art Director: Tony Seddon

Reprographics in Singapore by ProVision (Pte) Ltd.
Tel: +65 6334 7720
Fax: +65 6334 7721

Printed in Singapore by Star Standard Industries (Pte) Ltd.

500

Composition

Hints, Tips, and Techniques

for Photographers

The Easy, All-in-One Guide to those
Inside Secrets for Getting Better Shots

Lee Frost

Contents

The Basics

Break The Rules

Technique

In-camera Composition

Pictures For Profit

Image Improvement

After The Shot

Introduction

Composition is a strange concept—mainly because it isn't something you can put your finger on. If a photograph is badly exposed, it's obvious because the image appears too light or too dark. If it's unsharp, we can see that it's unsharp. But composition isn't like that—it's rarely something we comment on in a picture.

When did you last look at a photograph and say, "Wow, what a fantastic composition"? You might notice the quality of light, but composition is just there and taken for granted. It's the foundations that hold up the magnificent building, the drummer in the rock band, the supporting actor—absolutely essential to the success of the end product but rarely at the forefront and hardly ever celebrated.

Unfortunately for many photographers it's also the one thing that lets their pictures down. They've got all the equipment and know how to use it, are quite prepared to rise at 4am and walk for miles in search of the perfect view, but, when it comes to the moment of truth, all that hard work and effort is in vain because, although technically perfect, aesthetically their pictures are just uninspiring.

The main reason for this is that taking photographs is essentially a technical process that can be learned simply by picking up a book—using a camera, understanding exposure, mastering depth of field, knowing which filters to use—but composition is different. It's the creative, intuitive part of photography

that is 100 percent down to you, and, although you can learn the basics of composition by reading about the subject and studying the work of other photographers, the only real way to master it is by going out there, taking pictures, and trying to develop an understanding of why some things work compositionally while others don't.

In truth, composition isn't a difficult concept to grasp—all you're doing is arranging the elements of a scene in your camera's viewfinder so they form a visually pleasing whole. A successful composition is balanced and stimulating to look at. It leads the viewer's eye around the frame so it takes in all the important elements without any great effort. An untidy composition does the opposite. It leaves the eye wondering exactly where to go and fails to hold the attention of the viewer for more than a few seconds.

Every time we raise a camera to our eye to take a picture we're "composing," but the mistake many photographers make is not spending enough time deciding if what they've got in the viewfinder is actually interesting before capturing it. There's no magic formula

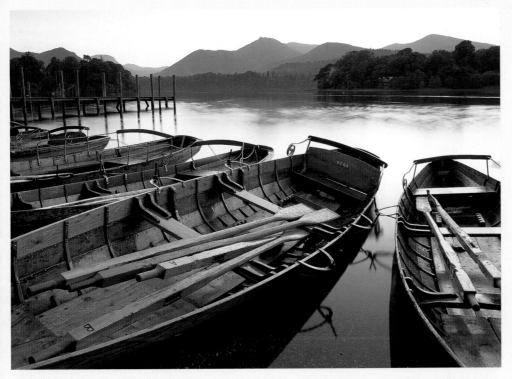

for composing a great picture. With subjects such as landscape and architecture it's a case of looking at what lies before you and then deciding how you can best photograph it by choosing a suitable viewpoint and controlling exactly what appears in the final picture by using the right lens.

Painters have a distinct advantage over photographers because they start off with an empty canvas then set about filling it, so if the natural composition of a scene isn't particularly inspiring they can move things around a little or add things that don't exist. As photographers,

our canvas is already full, so we have to decide which bits we want to capture. To help us do this there are various compositional "rules," devices, and tricks, and throughout this book we'll be looking at how to make the most of them.

The first step toward improving your compositional skills is recognizing and accepting the limitations a camera imposes compared with the naked eye and human brain. When we're out taking pictures we respond with all our senses. As well as seeing the colors, shapes, and textures of a beautiful scene, we also feel the sun

on our faces, hear birds singing, and smell the sweet fragrances of the great outdoors—wet grass after a spring shower, the scent of blossom drifting on the breeze. Consequently, our emotional response to a landscape is informed by all these things, even if we don't realize it at the time.

Unfortunately, the camera is a mechanical object that lacks any kind of emotion. It can only record what we want it to record, and the end result—a photograph—is merely a two-dimensional reproduction of what we saw. This is why so few photographs live up to our

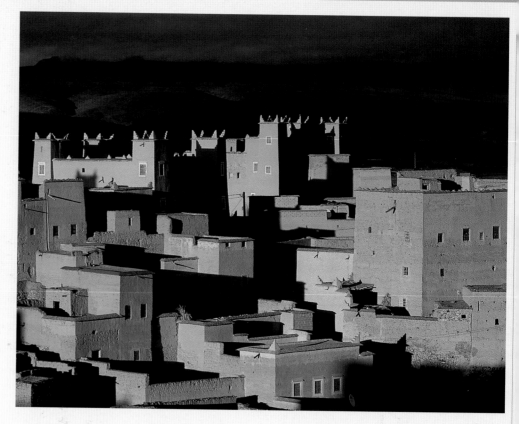

expectations. We vacation in paradise for two weeks and take hundreds of pictures, only to be disappointed when they seem dull and lifeless and fail to bring all those happy memories flooding back.

It's not that photography is incapable of doing this. A well-composed, well-lit photograph should not only be capable of generating an emotional response from you, the photographer, but people who weren't there when it was taken and didn't have the benefit of all the other sensory reactions that you enjoyed should be able to share the experience as well.

Another factor that you need to consider is that a photograph only records a tiny segment of a scene, rather like looking through a window, and offers no clues to what was going on beyond the parameters of the frame. Also, as a two-dimensional medium, a photographic image does not record depth and can only offer clues to its existence. Our eyes work in a completely different way. For a start, we have two, each offering a slightly different view that, when combined, give a strong impression of depth and spatial relationship. You can test this for yourself by looking through a pair of binoculars. Try looking first with one eye closed, then the other, and finally with both eyes open, and the three-dimensional effect of having two "viewfinders" will become obvious.

Our eyes work in harmony with the brain, constantly sending signals that generate responses based on previous experiences logged in our memory. We scan across the scene taking in different elements, and, although the angle of view of the naked eye is relatively narrow, it's amazing how much information we can gather in the space of a few seconds, which is then passed to our brains and processed, so a full picture of the scene is created. We do this without thinking, it's a natural response, but the camera can only record what

you point it at. Successful composition is, therefore, dependent on your ability to look at a scene and decide exactly where to point the camera so the images recorded capture the drama and grandeur of the broader view.

The aim of this book is to help you do just that, and to explore all the other factors—both technical and creative, in-camera and in-computer—that will help you compose pictures to be proud of.

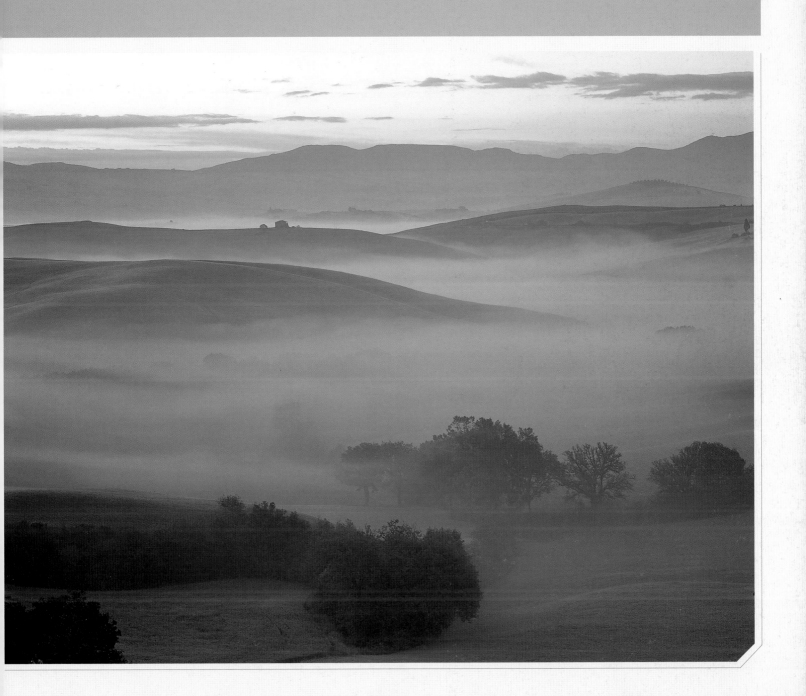

Gallery: take pictures with impact

Composition is about putting pictures together in a visually interesting way, thus creating images that stimulate the senses and hold the attention. The world is full of subject matter; all you have to do is go out there and capture it.

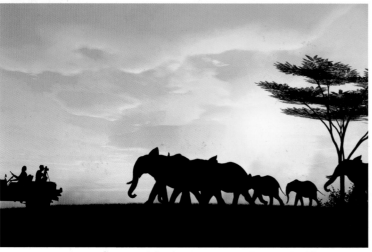

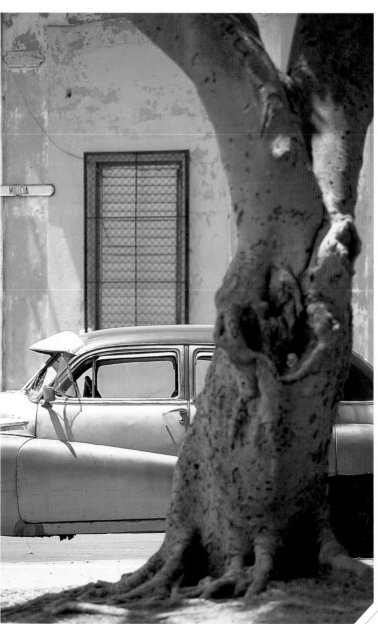

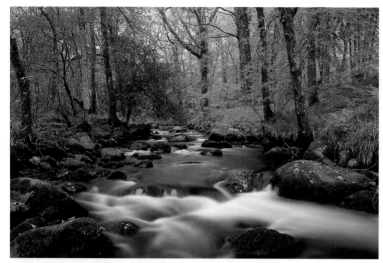

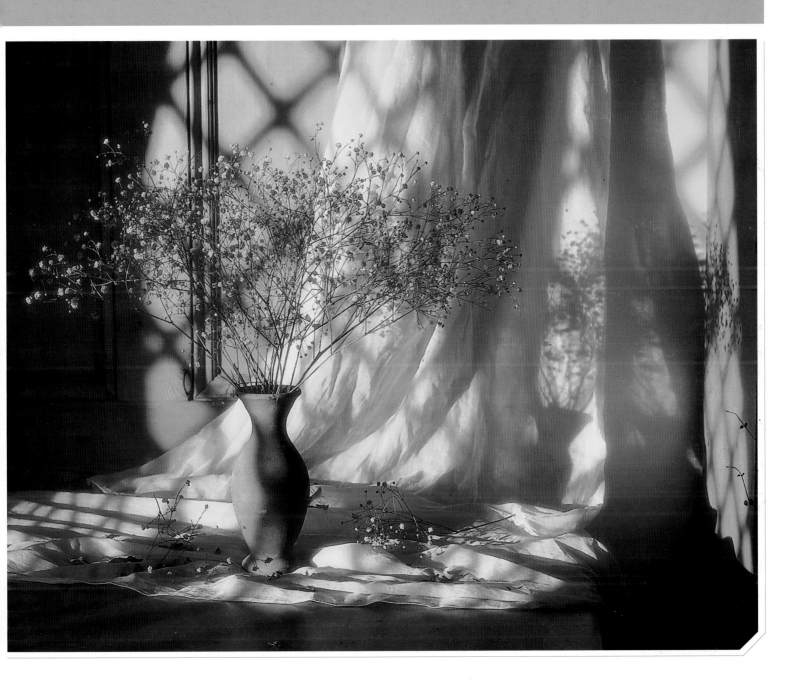

The Basics

Camera formats
The first factor that dictates the way a photograph is composed is the image format you use, and although the rectangular format popularized by 35mm single-lens reflex (SLR) cameras and, more recently, by digital cameras is by far the most common, there are other options worth considering that will allow you to photograph the world in a more interesting way.

Shooting in landscape format

The majority of pictures we take are shot with the camera in landscape format. This is partly because cameras are made to be held this way but also because it's a natural way of viewing a scene, with the eye scanning across the horizon. The landscape format emphasizes the horizon and produces photographs that are restful to look at.

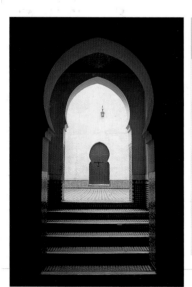

002 Turn the camera on its side

Turning the camera on its side produces more dynamic images because the eye scans the image from bottom to top rather than side to side. It also allows you to emphasize height and make a feature of vertical structures such as buildings.

003 Rectangle or square?

Although most photographers use cameras with a rectangular image format, the square format–traditionally 2¼ x 2¼in (6 x 6cm)–is favored by some. Square images have symmetry and balance and are more restful to look at. Of course, you can crop rectangular images to a square later if the subject suits it.

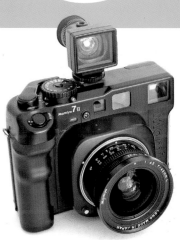

004 Panoramic views

The panoramic format is ideal for creating images that have a strong narrative quality and have the ability to hold the attention for much longer than pictures taken in traditional formats–simply because there's so much to take in, whether you use a panoramic camera, as below, or digitally stitch a sequence of images together.

005 SLR or rangefinder?

SLR cameras give you through-the-lens (TTL) viewing, so what you see through the viewfinder is what you get in the picture. Rangefinder cameras have separate viewing and taking systems so you're not looking through the lens. This makes it trickier to use filters such as polarizers and graduates that need careful alignment. However, rangefinders are smaller, lighter, and quieter than SLRs, so they're ideal for reportage and street photography.

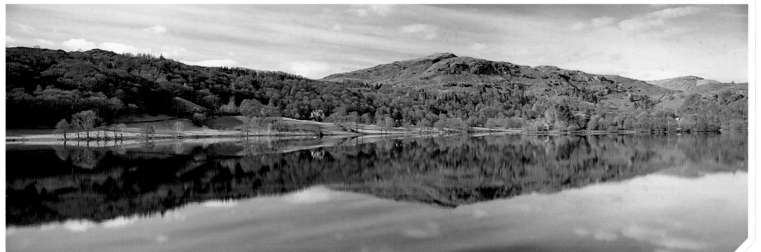

006 Is bigger better?

In predigital days, it was always said that the increased image quality of medium-format made it superior to 35mm, and large-format beat medium hands down. Now, with digital, it's how many megapixels your camera is capable of resolving. Ultimately, however, a photograph's success is, first and foremost, based on its visual impact and not how sharp it is, so forget about how big or small your camera is and concentrate instead on the technical and creative side of photography.

007 Take two (upright and horizontal)

Not sure whether a picture works best composed in landscape or portrait format? Then take one of each and decide later—it may be that both work equally well. If you're a digital-camera user you don't have to worry about film and processing, so shoot away and cover all bases. It's the best way to learn and improve.

008 Digital or film?

When it comes to composition, it doesn't matter whether you shoot digitally or expose film, the same rules apply, and in both cases you should always strive to compose in-camera as you want the final image to look rather than working on the basis that you can fix it later.

009 Using a pinhole camera

Although we take lenses for granted, you don't actually need one to record an image—the early pioneers of photography used nothing more than a pinhole, and, even today, pinhole cameras have a devout following among creative photographers. Make your own or buy one—either way you'll have lots of fun and discover a whole new world of working. The image below was made using a 5 x 4in (12.5 x 10cm) pinhole camera with an effective focal length of 75mm and an aperture of f/218. The exposure was three minutes on ISO 100 film.

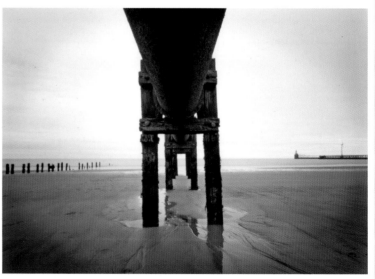

010 Twin-lens reflex

Old twin-lens reflex (TLR) cameras are great for portraiture because you view the subject through one lens and take the picture with another—so, when you trip the shutter, you don't lose sight of your subject during exposure. They can be picked up for bargain prices and offer a cheap route into the world of medium-format photography.

011 Shooting from waist level

Cameras with waist-level finders can aid composition because you're seeing the image from a distance and can view it more easily—although the image is laterally reversed (back-to-front), so they take a little getting used to.

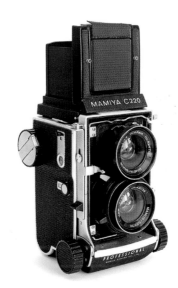

012 Eye-level prisms

All digital SLR and 35mm film cameras use a prism to reflect the image passing through the lens to your eye. They also correct the image, so what you see is what you get, making the camera quick and easy to use.

013 Large-format benefits

Image quality is only one benefit of large-format cameras like the 5 x 4in (12.5 x 10cm) Ebony shown here on the right. They also allow you to change perspective and maximize/minimize depth of field by adjusting the position of the lens in relation to the film plane and vice versa. Architectural photographers can also correct converging verticals when shooting buildings.

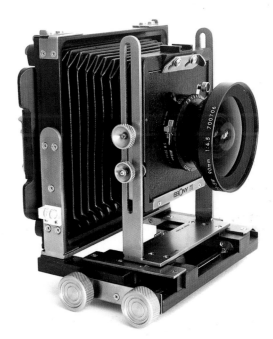

014 No peeking

So much of photography is predictable in this digital age that there are rarely any happy accidents. But you can make them happen. Try shooting without looking through the camera's viewfinder or at its preview screen—just hold the camera out and fire away at random. This technique works particularly well in towns and cities where there's always something to fill the frame.

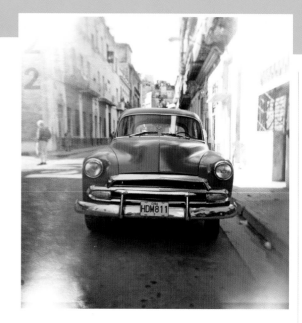

015 Instant images

Polaroid instant cameras are great fun to use. Not only do they allow you to see the results within minutes of tripping the shutter–a low-tech alternative to digital capture!–but the images also have a unique look that can't be achieved any other way. The folding SX70 cameras are a modern classic and have a big following among creative photographers–well worth a search on eBay or at your local flea market.

016 Fun with toy cameras

The Holga "toy" camera, which costs as little as $25 to buy, has achieved legendary status in recent years thanks to its cheap, plastic construction and unique image quality–complete with vignetting and light leaks! Exposure controls are limited to one aperture and one shutter speed plus B (bulb), but that's all you need to create amazing images. Give it a try–you'll be hooked.

017 Carry a compact

Small digital compact cameras are ideal for slipping into your pocket and carrying around so you never miss the chance to grab an interesting photo. Why not set yourself a challenge to take at least one photograph every day and create your very own photoblog?

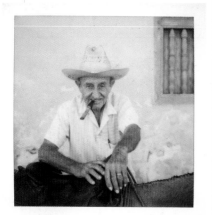

018 Change your focusing screen

Many SLRs have interchangeable focusing screens, so if the basic screen your camera came with doesn't suit you, consider switching to a different one. Grid screens can be a great compositional aid, while extra bright screens are ideal for low-light photography.

019 Different formats for different jobs

Don't feel that you have to limit yourself to just one camera format. All-square, rectanglar, panoramic–have their uses and will help you make the most of a situation.

Keep it steady

If you want to get the most from your cameras and lenses and produce photographs that are as sharp as a razor, you'll need to learn how to support them.

020 How to hold your camera

How you hold your camera can make all the difference between a picture being pin sharp or ruined by camera shake.

- Stand with your back straight and your feet slightly apart.
- Hold the camera with both hands and tuck your elbows into your side to aid stability.
- Squeeze the shutter and release gently rather than jabbing it.
- Depress the shutter after exhaling so your body is relaxed rather than tense.
- Kneeling or sitting down will provide more stability when using long or heavy lenses.

021 Support the camera

If light levels are low and you're forced to work at a shutter speed that's too slow for handholding, look for things that can be used to help keep the camera steady.

- Press the camera against a post or tree and use that to provide stability.
- Rest the camera on a wall or post, perhaps using a jacket or camera bag to cushion it.
- Use the frame of an open car window as a support.

022 Tripod choice

A tripod provides the best form of camera support, allowing you to use exposures of seconds, minutes, even hours, and still produce sharp images. Buy a model that will extend to eye level without the need for a center column, and make sure it's solidly built. Carbon-fiber tripods are ideal, as they're lighter than alloy models but just as stable.

023 Ultimate image quality

Achieving ultimate image quality is easy if you're willing to put a little effort into your photography.

- Keep your camera's ISO as low as possible—whether digital or film, the lower the ISO the sharper the image will be. As ISO increases, noise/grain become more obvious.
- Buy the best lenses and filters you can afford and keep them clean—dust and grime on optical surfaces reduces image quality.
- Lenses generally give their best optical performance in the middle of the aperture range (f/8-f/11) and their worst at the widest and narrowest aperture settings.
- Mount your camera on a sturdy tripod and trip the shutter with a cable release to avoid camera shake.

Lens choice

Lenses are the most powerful compositional tool at your disposal, not only allowing you to control what's included in a picture but also how perspective is recorded and how much—or how little—comes out sharply focused.

 ## Wide-angle lenses

Any lens with a focal length of 35mm or less is considered wide angle. For scenic photography, this is the most versatile lens type, offering a broad field of view and "stretching" perspective so that the elements in a scene appear more widely spaced than they do to the naked eye. Wide-angle lenses also give you lots of depth of field to work with when set to small apertures such as f/16 or f/22, so you can record the whole scene in sharp focus from the immediate foreground to infinity. For general use, 24mm and 28mm are the most popular focal lengths.

 ## Using telephotos

Any lens with a focal length greater than 50mm is considered telephoto. The most obvious characteristic is the fact that tele lenses magnify the subject so it appears bigger in the viewfinder than it does to the naked eye. This means you can isolate distant subjects and make them fill the picture area, exclude distracting elements, and emphasize things such as pattern, texture, and color. The longer the focal length, the narrower the field of view will be. Telephoto lenses also appear to compress perspective, so the elements in a scene appear more crowded together—an effect known as foreshortening. Finally, depth of field is reduced with tele lenses so you can throw backgrounds out of focus and make your main subject the center of attention.

 ## Standard lenses

In 35mm format, the standard lens is 50mm. This focal length has a similar angle of view to the human eye and also records perspective similar to how our eyes see it. The standard lens is thus ideal for producing images with a natural perspective, suiting all subjects, from portraits to landscapes. Standard lenses are also small, lightweight and have a fast maximum aperture—typically f/1.8 or f/1.4—making them ideal for handheld photography in low light.

 ## Ultra-wides

Once focal length falls to 20mm and below you're into the territory of extreme wide-angle lenses, where angle of view is vast, depth of field never ending, and perspective stretched to the point that anything more than a few inches from the camera appears to be miles away! Distortion at the frame edges is also common, and verticals converge dramatically with the slightest upward tilt of the camera. This all combines to produce dramatic images, but ultra-wides need to be used with care if you're to avoid empty, lifeless compositions.

Angle of view

The amount a lens actually sees and records depends on its angle of view, which is expressed in degrees. The wider the lens, the bigger its angle of view and vice versa. The 50mm standard lens has an angle of view similar to the naked eye, while wide-angle lenses have an angle of view that's greater, and telephoto lenses a smaller one, as shown by the illustration below.

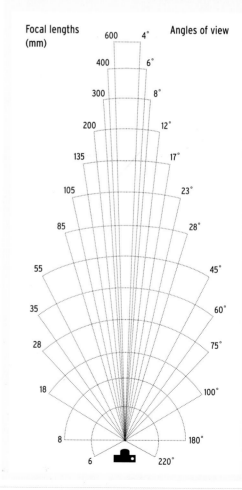

028 Extreme telephotos

Telephoto lenses longer than 400mm are considered extreme. They push all the telephoto characteristics to the limit–angle of view is down to just a few degrees, depth of field is almost nonexistent, and perspective compression is dramatic. Such lenses are big, heavy, and generally expensive, so they're not advised for general use. However, for nature and sports photography, lenses as long as 500mm or 600mm are invaluable.

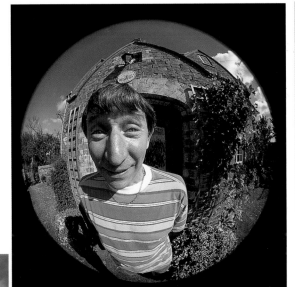

029 Fisheye Fun

If you want to record the world in a totally wacky way, consider a fisheye lens. With a 180-degree angle of view you can cram an incredible amount into one image and also bend straight lines and distort shapes to produce amazing effects. Full-frame fisheye lenses use the whole image area, while circular fisheyes produce a circular image within the image format. Cheaper adaptors can be fitted to wide-angle lenses to create the same effect.

030 Avoiding Flare

Flare is common when shooting with the sun or a bright light source just out of shot, especially when using wide-angle lenses. Purpose-made lenses will help to avoid it, but a piece of card also makes an excellent shade that can be held in any position. Failing that, use your hand–but be careful not to include it in the picture!

031 Using a shift lens

If you're shooting architecture and want to avoid converging verticals, a shift lens is the best option. The front elements of a shift lens–also known as a perspective-control (PC) lens–can be adjusted so that you're able to include the top of the building in the picture without tilting the camera back, which is the very thing that causes converging verticals.

032 Macro lenses

If you want to produce true macro images, nothing beats a purpose-made macro lens. The most common focal lengths are 100mm or 105mm and this allows very close focusing and a reproduction ratio up to 1:1 (lifesize) without the need for accessories or adaptors. Image quality is generally very high, and the lenses are also ideal for portraiture.

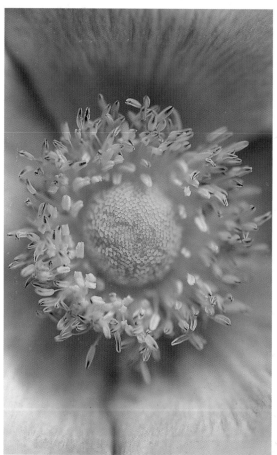

033 Magnification factor for digital SLRs

Although some Canon digital SLRs have a sensor the same size as a 35mm film frame, the majority of DSLRs have a sensor that's smaller, so the effective focal length of lenses fitted to them is increased, as shown here:

Focal length for 35mm and full-frame sensors	Magnification factor (mf) of 1.3	Magnification factor (mf) of 1.5
17mm	22mm	26mm
20mm	26mm	30mm
24mm	32mm	36mm
28mm	36mm	42mm
35mm	45mm	52mm
50mm	65mm	75mm
70mm	90mm	105mm
100mm	130mm	150mm
135mm	175mm	200mm
200mm	260mm	300mm
300mm	390mm	450mm
400mm	520mm	600mm
500mm	650mm	750mm
600mm	780mm	900mm

034 Prime or zoom?

Zoom lenses are more versatile than prime (fixed focal length) lenses as you can perfect the composition of a picture by making small adjustments. The image quality of zoom lenses is also now on a par with prime lenses—that said, don't use your zoom lens as a substitute for actually moving yourself and the camera. Also, a 50mm prime standard lens is also a useful inclusion in anyone's camera system.

035 Fast or slow?

A lens is considered fast if the maximum aperture is wide for its focal length or zoom range. For example, any zoom lens with a maximum aperture of f/2.8 is said to be fast, as is a 50mm f/1.4 or a 500mm f/4. The benefits of a wide maximum aperture are a brighter viewfinder image and the ability to use faster shutter speeds—which can make all the difference when shooting moving subjects or working in low light. However, fast lenses are bigger, heavier, and more expensive than lenses with the same focal length or zoom range and a smaller maximum aperture, a 70-200mm f/4.5-5.6 lens compared with a 70-200mm f/2.8, for instance.

036 Zooming

You can create wacky effects using a zoom lens by adjusting the focal length during exposure so your subject records as an explosion of colorful streaks. Here's how it's done:

- For the best results, choose a simple, bold subject—people, flowers, trees, and vehicles are ideal.
- Make sure a shutter speed of 1/8 second or slower is set so you have enough time to zoom the lens while the camera's shutter is open.
- Set the zoom to its longest focal length and focus on your subject.
- As you gently press the camera's shutter release, start zooming the lens toward the wider end of the focal-length range.
- Zoom smoothly and evenly and continue through to the end of the focal-length range even if the shutter has already closed.
- All being well you'll end up with a result like the one below.

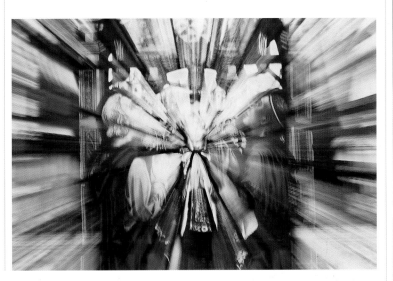

037 Mirror lenses

These are telephoto lenses, typically with a focal length of 500mm or 600mm, that use a special design so that the physical size of the lens can be reduced—the light entering the lens is reflected back and forth by mirrors. One characteristic of the mirror lens is that out-of-focus highlights record as doughnut-shaped rings.

038 The ideal lens range

For general use, a selection of lenses covering effective focal lengths of 28-300mm is more than sufficient and will allow you to photograph all subjects. This can be covered by a pair of zoom lenses–28-70mm and 70-300mm. Wider and longer lenses only become necessary if you specialize in areas that demand them.

039 Isolating details

Use your telephoto and telezoom lenses to isolate details–look for patterns, both natural and manmade, texture, and abstracts created by the juxtaposition of colors and shapes. The urban landscape of towns and cities is a great hunting ground for details, although the natural world is very productive too.

040 Scene within a scene

Often, you'll find that one scene contains many different photographs once you begin to explore it. For example, a wide-angle lens can be used to take the initial broad view, but then, with a telephoto or telezoom lens fitted to your camera, you can concentrate on specific areas and create simpler, more selective compositions. Moving into the scene, you may also be able to use a macro lens to capture small details that help to tell a more intimate story of a single scene.

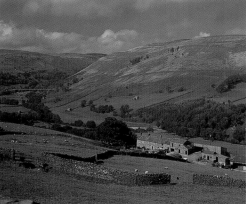

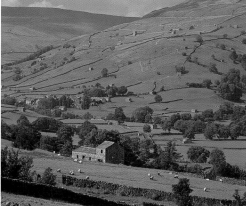

041 Handholding lenses

The rule of thumb to avoid camera shake when taking handheld shots is to use a shutter speed that matches the focal length of the lenses: 1/30 second with 28mm or wider, 1/60 second with 50mm, 1/250 second for lenses with a focal length less than 200mm, 1/500 second with 300–500mm lenses, and so on.

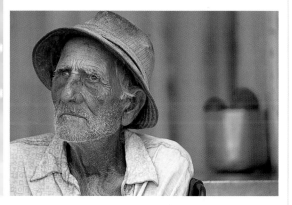

042 Deciding which lens to use

The more lenses you carry, the harder it becomes to decide which one to use for any given shot—and if you're not careful you'll miss opportunities while making your selection. So only carry what you need—two or three lenses should be more than enough—and get to know each one so you instinctively know which to use and when.

043 Simple lenses

A relatively new accessory that's becoming very popular is the Lensbaby. It fits directly to your camera instead of a lens and has a flexible bellow arrangement that you can move around to achieve selective focus as well as creating interesting soft-focus effects. The lens from a Holga camera (see tips 016 and 492) can also be mounted directly onto a digital SLR to produce unusual results. Sharpness isn't always crucial!

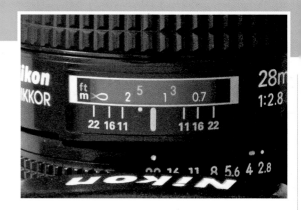

Focusing and depth of field

Being able to assess and control what will be in and out of focus in a photograph is vital if you want to achieve compositional success, because it will influence the mood and visual impact of every picture you take.

 ## What is depth of field?

The zone of sharp focus in a photograph that extends beyond and in front of the point you actually focus the lens on is known as the depth of field.

 ## Varying depth of field

There are three factors that reduce or increase depth of field:

- First, the aperture the lens is set to. The smaller it is (the bigger the f/number) the greater depth of field is and vice versa. So depth of field is maximized by stopping down to the smallest aperture—usually f/16 or f/22, depending on the lens—and minimized by setting the maximum aperture, f/2.8 or f/5.6, for example.
- Second, the focal length of the lens. The smaller it is (and the wider the angle of view) the more depth of field you get at any given aperture setting and vice versa. So a 24mm lens set to f/8 will give less depth of field than a 17mm set to f/8 but more than a 50mm lens set to f/8.
- For any given focal length or aperture, the closer you focus the lens, the less depth of field there will be and vice versa. A 50mm lens set to f/16 will give much less depth of field if you focus it on 3ft (1m) than if you focus it on 33ft (10m), for example.

Many cameras come with a depth of field preview facility that allows you to quickly and roughly check what will record in and out of focus in a shot before you take it. It does this by manually stopping the lens down to the aperture.

 ## Depth of field scales

Some prime lenses have a depth of field scale, which allows you to assess roughly the nearest and farther points of sharp focus. In the example above, you can see that with this 28mm lens focused on 6ft (2m) and set to f/16, depth of field will extend from approx 3ft (1m) to infinity. Many modern autofocus lenses lack these scales, unfortunately, but they are found on older 35mm SLR lenses and most medium-format lenses.

Depth of field is great when...

You use a wide-angle lens such as 20mm or 24mm set to a small aperture such as f/16 or f/22.

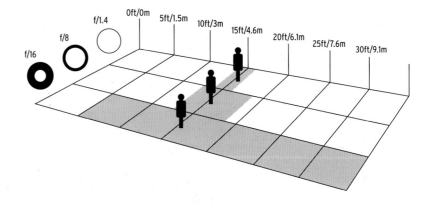

048 Depth of field is small when...

You use a telephoto lens such as 300mm or 400mm set to its widest aperture such as f/5.6 and focus on a point relatively close to the camera.

049 Using extensive depth of field

When shooting landscapes you will generally want to record the whole scene in sharp focus, from the immediate foreground to infinity. This is easy to achieve with a wide-angle lens set to a small aperture–although you'll need to use the hyperfocal focusing technique to truly maximize depth of field (see tip 050).

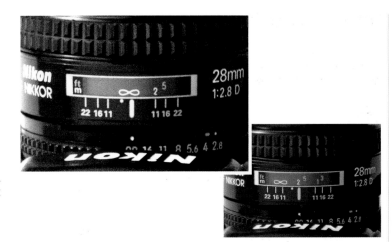

050 Hyperfocal focusing

This is a technique that allows you to maximize depth of field so your pictures are sharply focused from the foreground to infinity. To use it, focus your lens on infinity then check the depth of field scale to see what the nearest point of sharp focus will be at the aperture set–this is the hyperfocal distance. In this example, at f/11 the hyperfocal distance is roughly 6ft (2m). Now refocus your lens on the hyperfocal distance, and depth of field will extend from half the hyperfocal distance to infinity.

051 Using shallow depth of field

If you want to throw the foreground and, more so, the background out of focus so your main subject stands out, use a telephoto lens set to its widest aperture so depth of field is shallow.

Depth of field made easy

If your lenses lack depth of field scales, use the table on the right to maximize depth of field. Find the effective focal length of your lens along the top (the focal length after applying any magnification factor for your DSLR) then read down until you reach the aperture (f/number) you intend to use. The distance that corresponds to these two values is the hyperfocal distance. By focusing on this, depth of field will extend from half the hyperfocal distance to infinity. For example, if you're shooting at a focal length of 24mm and you stop the lens down to f/16, by focusing on a point 3ft (1m) away, everything will record in sharp focus from 18in (0.5m) to infinity.

Lens focal length (mm)

Aperture (f/stop)	17mm	20mm	24mm	28mm	35mm	50mm	70mm	100mm	200mm
f/8	1.0m	1.4m	2.0m	2.8m	4.2m	8.5m	17m	35m	140m
f/11	0.75m	1m	1.5m	2m	3m	6.3m	12.3m	25m	100m
f/16	0.5m	0.7m	1m	1.4m	2.1m	4.3m	8.5m	17.5m	70m
f/22	0.35m	0.5m	0.7m	1m	1.5m	3.1m	6.2m	12.5m	50m
f/32	0.25m	0.35m	0.5m	0.7m	1m	2.2m	4.2m	8.5m	35m

052 Autofocus or manual?

Modern autofocus systems are very fast, accurate, and reliable, and in any situation where you need to grab shots quickly they can be invaluable. However, it's difficult to maximize depth of field with your lenses set to AF mode because you need to control the distance the lens focuses on, so focusing manually is recommended. If critical focus is required and depth of field is limited—when shooting close-ups, for example—you should also switch to manual focus.

053 When your autofocus lens refuses to focus

Despite advances in autofocus technology, occasionally you may find that your lenses struggle to focus accurately. Flat, plain surfaces such as white walls or washed-out sky tend to be problematic because there's no texture or contrast for the lens to detect. If this happens, switch to manual focus and rely on your eye instead.

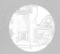

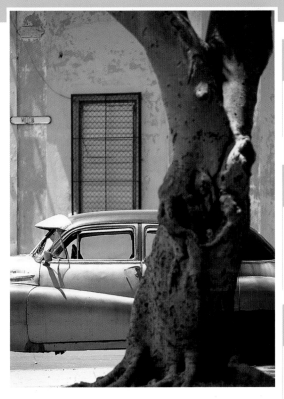

055 What to focus on?

You decide. There are no hard-and-fast rules. It's tempting always to focus on what's in the middle of the picture as that's where the main autofocus sensor in your camera's viewfinder will be found. But focusing on an off-center subject often results in more interesting images.

056 Manual focusing with autofocus lenses

The manual-focusing ring on AF lenses and zooms isn't always well-placed—often it's at the very end of the lens—and the focusing action can be rather loose. These two factors can combine to make critical manual focus difficult, so take care and take time.

057 Shoot in aperture-priority mode

Aperture-priority (AV) mode is the most useful for day-to-day shooting because you get to select the aperture (f/number) a picture is taken at so you have control over depth of field. The camera will then automatically set a shutter speed to achieve correct exposure.

054 Focusing through obstructions

Autofocus lenses may also "hunt" and refuse to lock focus if anything obstructs the sensors in the viewfinder. For example, if you want to focus on something in the distance and there are people, buildings, trees, or other elements close to the camera, your lens may decide to focus on them instead. Shooting through glass can also confuse a camera's AF system if there are reflections on its surface, as the lens may focus on the glass instead of what you were hoping to shoot. In all cases, manual focusing is the solution.

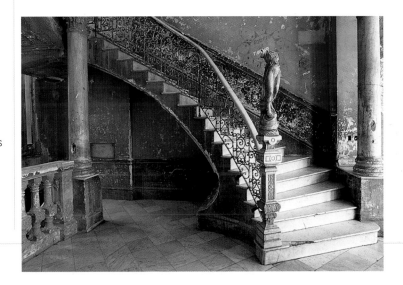

058 Defocusing for effect

Photographs don't always have to be sharply focused–sometimes, intentionally defocusing the lens will produce fantastic images because they make the viewer do a double take. Stick to bold, colorful subjects for the best results.

059 Prefocusing

If you're photographing a moving subject, and you can predict its path, prefocus the lens on a point you know it will pass then press the shutter release just before it reaches it. This is a useful technique for such sports as cycling, horse racing, and other track events where the competitors follow a predictable route.

060 Follow-focusing

If you can't predict your subject's path, then you need to track it with your camera and continually adjust focus to keep it sharp in the viewfinder until you're ready to take a shot. The Predictive or Servo AF found in modern SLRs will do this for you automatically.

061 Panning the camera

A great way to inject a sense of motion into your pictures of moving subjects is by panning the camera while shooting so that your main subject comes out relatively sharp while the background blurs. For fast-moving subjects such as cars you can use a shutter speed of 1/250-1/500 seconds, while for slower subjects, experiment with speeds down to 1/4 or 1/2 second.

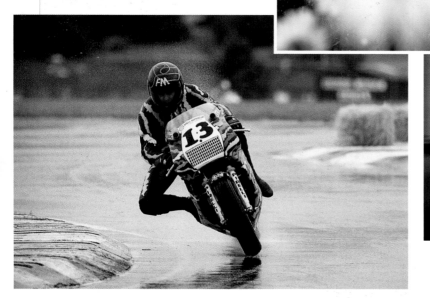

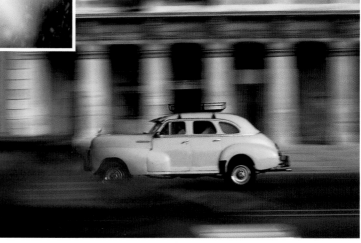

062 Using a tripod

Mounting your camera on a tripod eliminates the risk of camera shake, so you can set the lens to a small aperture to achieve extensive depth of field without worrying how slow the shutter speed is. It's also easier to focus with precision if the camera is stable—handy for macro photography, where depth of field can be just a fraction of an inch.

063 Shoot from the hip

If you need to grab a picture without anyone realizing—when shooting candids, for example—hold the camera at waist level, point the camera toward your subject, and fire away. You'll have to guess the composition, and you may have to crop or level the image later if it's out of kilter, but that's better than getting no picture at all.

064 Adding blur

Don't feel that your subject, or indeed a picture, must be pin sharp—by intentionally adding blur you can create some amazing effects. Try shooting a moving subject using a slow shutter speed, or intentionally move the camera during exposure so the whole image blurs.

065 Differential focus

This technique involves shooting with a telephoto lens set to its widest (maximum) aperture so that depth of field is minimal. Select your main subject and focus carefully on it so that the foreground and background are thrown out of focus to create a strong three-dimensional effect. For the best results, include elements in the composition that are close to the camera or shoot between structures so that these out-of-focus features draw the eye toward your main subject.

The rule of thirds

Balance is often the key to compositional success, and one technique that will help you achieve that is the good old rule of thirds.

066 Creating the grid

To use the rule of thirds you need to divide your camera's viewfinder into an imaginary grid of nine segments, using two vertical and two horizontal lines—as shown on the right. Focusing screens marked with a grid are useful here, but you can imagine the grid quite easily.

067 Positioning the focal point

To achieve compositional balance when using the rule of thirds, place your main focal point on one of the four intersection points created by the imaginary lines. The focal point is the element in a composition that you want the viewer to be drawn to—whatever it may be.

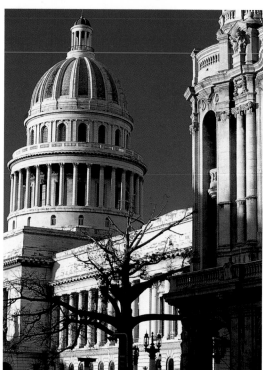

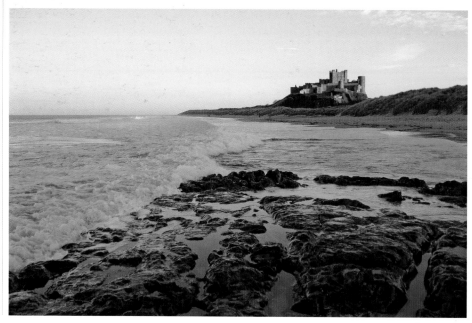

068 Vertical features

Use the two vertical lines in the grid to help you position strong vertical elements and divide the frame in a more visually interesting way—a person can be placed off-center, for example, as can other features such as trees and buildings.

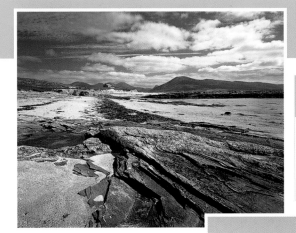

071 Make the most of foreground interest

When shooting landscapes, you will normally want to emphasize the foreground. To do this, place the horizon on the higher horizontal line of your imaginary grid, so the sky only occupies the top third of the picture area and the foreground fills the rest.

069 More than one focal point

A composition can have more than one focal point, but, to avoid a cluttered composition, care is required when it comes to their placement in the frame. Use the rule of thirds if you can, at least for the primary focal point, and shoot from an angle that allows the eye to move from one focal point to the next.

070 Emphasize the sky

If you want to make the most of a dramatic sky, position the horizon on the lower horizontal line in the grid so the landscape occupies the bottom third of the frame and the sky occupies the rest.

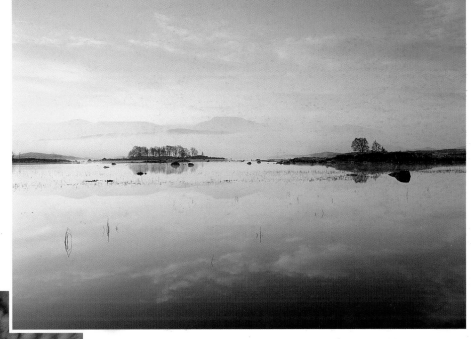

072 Don't force it

Although the rule of thirds is a handy compositional aid, don't force your pictures to conform to it—not every scene or subject will suit this treatment. Anyway, aren't rules there to be broken?

Technique

Using color
Colors can be warm or cold, strong or weak. They can harmonize or contrast and vary in tone from bold primaries to subtle secondaries. One thing's for certain though: color, and the way you use it, can make or break a photograph because it has a huge impact on the reaction of the viewer.

073 The color wheel

Light is formed by the colors of the spectrum, which we also see when a rainbow is formed. Arranging these colors around a wheel is a good way of understanding how they relate to one another. On one side, there are the warm colors–magenta, red, and yellow–and on the other, the colder–green, cyan, and blue. These are the primary colors (red, green, and blue) and their complementaries (cyan, magenta, and yellow). Colors on opposite sides of the color wheel are said to clash or contrast, while colors that are close together harmonize.

074 Quality of light

The way colors record outdoors is influenced by the quality of light. Early and late in the day the light is naturally very warm, so colors appear warm. In the middle of the day, with the sun overhead, the light has a slight coolness, so colors appear cooler. Color saturation is at its highest when the light is slightly diffused rather than the hard light of full sun. Colors appear very rich in open shade because the light is soft and contrast low. Backlighting reduces color saturation.

075 Weather conditions

The weather affects the quality of light in a big way. In clear, sunny weather, colors appear bright and well saturated. Different colors are also clearly defined. Dull, overcast weather makes colors appear much softer, while mist merges colors, making the difference between warm and cold hues less obvious and all colors to appear to harmonize because they are so muted. Dense fog can make a normally colorful scene appear monochromatic.

076 Contrasting colors

Colors opposite each other on the color wheel are said to contrast–such as yellow and blue or red and green. Including them together in a picture works well because the resulting image jars the senses and attracts attention. For the best results, shoot in strong light and include the colors in equal quantity so that one doesn't dominate the other.

077 Harmonious colors

Colors that are close to each other on the color wheel harmonize—such as yellow and red, yellow and green, green and blue, and so on. Different shades of the same color also harmonize well. Color harmony is useful in composition because it allows you to produce images that are easy on the eye. Think of the warm colors of a woodland scene in fall or the glow of sunrise or sunset.

Color temperature

As a means of measuring the color differences in light—rather than just saying it's a bit blue or a bit orange—photographers use a system known as the Kelvin scale (K), which refers to light in terms of its color temperature. Normal light—the type you find on a clear, sunny afternoon—has a color temperature around 5,500 K, and colors record naturally. If color temperature rises above 5,500 K the light becomes cooler, and colors take on a slight blue cast, as on a dull day; if color temperature drops below 5,500 K it becomes warmer, and colors take on a yellow/orange cast, as at sunrise and sunset.

Our eyes adapt to these changes in the color temperature of light, so colors always appear more or less natural. However, photographic film and digital sensors can't—they record light as it really is—so steps may need to be taken to avoid unwanted color casts. With film you can use colored filters (as recommended below). With digital cameras you can use Auto White Balance (AWB) or change the Kelvin sensitivity of your camera's sensor using the White Balance setting.

Color casts aren't always undesirable, of course. The color temperature at sunset can be as low as 3,000 K, but you wouldn't want to filter out the warmth in the light because it makes your pictures look far more attractive.

Light source	Color temp	Filtration
Shade under blue sky	7,500 K	Orange 85B
Under cloudy sky	7,000 K	81D warm
Average daylight	5,500 K	None
Electronic flash	5,500 K	None
Afternoon sunlight	4,500 K	NR
Early morning/evening sunlight	3,500 K	NR
Tungsten photofloods	3,400 K	Blue 80B
Sunrise/sunset	3,000 K	NR
Domestic tungsten bulbs	2,800 K	Blue 80A + 80C

Candlelight 1,000 K
Sunrise or sunset 2,000–3,000 K
Household light bulb 3,000–3,500 K
Studio photoflood bulbs 3,200–4,000 K
Early-morning or late-evening sunlight 3,500–4,000 K
Midday sunlight 5,400 K
Electronic flash 5,500–6,000 K
Cloudy or overcast 6,000–7,000 K
Open shade 7,000–8,000 K

078 Single color

You can produce stunning pictures of scenes comprising just one color or the same color in different shades. Soft, hazy backlighting tends to create this effect in nature by bringing the colors closer together, but you'll also find manmade evidence of it too in the use of building materials and paint color.

079 Increasing color saturation

Slight underexposure of a photograph will make colors more deeply saturated. This works with both film and digital cameras, but you need to be careful not to overdo it, otherwise colors appear dark and muddy.

080 Use the Saturation slider in Photoshop

It might seem obvious to make colors appear stronger by increasing saturation using the Hue/Saturation control in Photoshop. However, while this can work well when used subtly—maybe +10 percent—if you go too far, colors will very quickly appear oversaturated and unnatural, so avoid the temptation!

081 Warm colors

Warm colors—such as orange and yellow—help to create images with a tranquil, soothing effect, especially when the tones are soft and gentle. This is why landscape photographers prefer to shoot at dawn and dusk, when daylight is naturally warm.

082 Monochromatic color

When a scene or subject consists of a single color or different shades of the same color, then that color is said to be monochromatic. Haze and dust can create this effect, especially at sunrise and sunset, when you shoot into the light and everything takes on a beautiful golden glow. The effect of this limited color palette can produce photographs full of atmosphere.

083 Cold colors

In cold or dull weather color bias moves toward blue, and the feel of your photographs will change completely, having a more somber, melancholy feel that can be just as effective as warm colors.

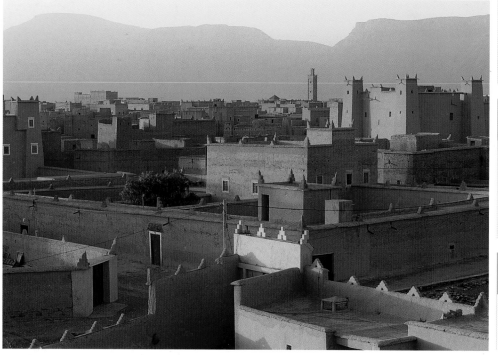

084 Graduated filters

Add color to insipid skies using colored graduated filters. Pink, mauve, pale red, and orange can add impact to photographs taken at sunrise and sunset—but don't expect the results to look natural.

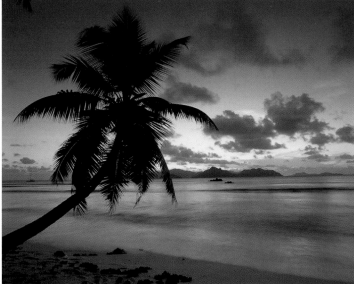

085 Reciprocity failure

If you use long exposures—30 seconds or more—a phenomenon known as reciprocity failure may occur, where unusual color casts are recorded. This can be surprising, but the results can also be very interesting and effective.

086 Abstract color

You can produce striking abstract images by exploiting areas of bold color and composing a subject or scene so that the colors are emphasized rather than the forms. Try excluding part of your subject so the obvious center of attention is missing, or frame it from an unusual angle.

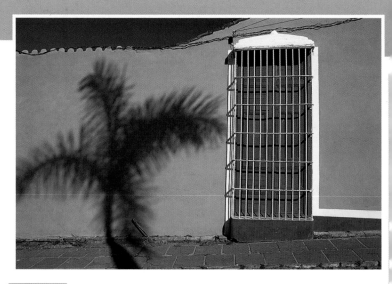

087 Colors that advance

Colors at the warm end of the spectrum are said to advance, because they stand out and demand attention. Red is the most powerful color in this respect, which is why it can dominate a photograph even when it only occupies a small area. Yellows and oranges also do this.

088 Colors that recede

Cool colors–blues and greens–are said to recede. This makes them great as background colors as they help to make other colors stand out, which is why areas of blue sky are so effective in photographs.

089 Dominant colors

Don't always be tempted to fill the frame with bold, clashing colors–a photograph will often be more successful if you let one powerful hue dominate the image so it becomes the focus of attention. The more intense the color, the more it will dominate, especially if it appears in the background to a more neutral or softer color.

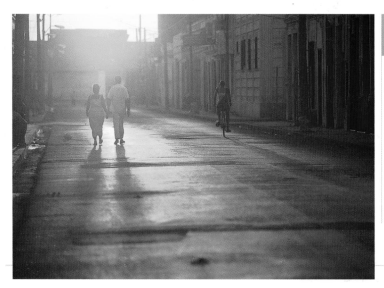

090 Color symbolism

The primary colors have great symbolic value, which you can use to great effect in your photographs:

- Red reminds us of anger, danger, love, passion, blood, and fire.
- Blue can be both soothing–it's symbolic of the sky, water, purity, and wide-open spaces–but, equally, it can be a cold, depressing color that reminds us of bad weather, loneliness, and sadness.
- Green is the color of nature–trees, fields, and hills. It symbolizes the great outdoors, new life, freshness, and vibrancy.
- Yellow is light, the sun, and pure gold. It's a happy, positive color that makes photographs soothing to look at and easy on the eye.

091 Isolating color

Use your telezoom or telephoto lens to isolate interesting areas of color and to exclude unwanted details from the frame. Changing camera angle may also allow you to create more interesting juxtapositions of colors.

092 Using color filters

Add color to your photographs with filters. The pale amber 81-series of warm-up filters are ideal for enhancing pictures taken at sunrise and sunset, while the pale blue 82-series filters will enhance cool colors and are ideal for shooting in dull, misty, or foggy weather. For a stronger color cast, use the blue 80-series and orange 85-series of color-conversion filters.

093 Make the most of your polarizer

A polarizing filter removes glare from nonmetallic surfaces and cuts through haze to make colors appear more deeply saturated, so use it whenever you want your photographs to have maximum impact. Don't limit its use to bright sunlight either—in dull, damp weather, glare is increased, so your polarizer will still do a great job of boosting colors. To deepen blue sky, keep the sun at roughly 90 degrees to the camera.

094 Increase the atmosphere

When the light is soft and hazy and colors are muted you can create beautiful, atmospheric images. To enhance the mood, use a soft-focus filter or breathe on the lens to create a misty effect. This works particularly well when you're shooting into the light and the subject is backlit.

095 Something from nothing

Why not set yourself a project to shoot a series of pictures where color is the sole subject? For example, your theme could be a given color, and your challenge is to find interesting things of that color to photograph. It's a great way to develop your eye for a picture.

096 Go close for impact

One of the most common compositional mistakes is not getting close enough to the main subject. So from now on, no matter how close you are, always take a few steps toward your subject and see what a difference it makes. Fill the frame with color.

097 Red-enhancing filter

This filter deepens colors at the warm end of the spectrum, especially reds, and it is ideal for photographs where warm hues dominate, such as the color of trees in the fall or landscapes at sunrise and sunset. A special glass called didymium is used in the filter's construction to achieve this effect.

099 Hand-coloring

A color photograph doesn't have to start out in color—why not make a black-and-white print then hand-color it with photo dyes? The same effect can also be achieved digitally, by selectively desaturating an image so only parts of it remain in color, or desaturating the whole image then adding color back so it looks like a hand-colored photograph.

098 Make your own pictures

You can create striking color photographs by collecting together interesting objects and composing still lifes. Place vibrant yellow flowers against a blue background, for example, and you have a powerful color contrast; children's toys and colorful items such as plastic picnic sets also make great subjects for color close-ups.

100 Twilight zone

Before the sun has risen or after it has set, the landscape is lit by light reflected from the sky so it often takes on a surreal blue cast that looks incredibly atmospheric. This is best seen in coastal areas as the color of the sky is reflected in the sea. Use long exposures to blur motion in the sea and add mood.

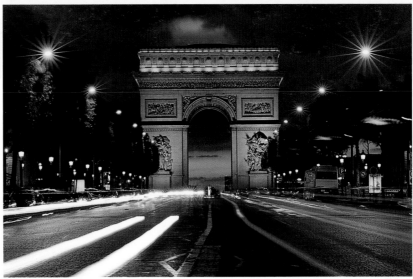

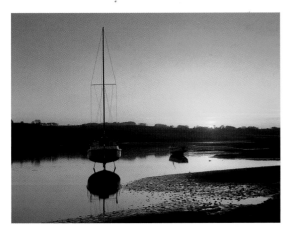

103 Manmade color

Various forms of artificial illumination–including sodium vapor, fluorescent, mercury vapor, and tungsten–create vivid color casts that can produce surprising effects when photographed because our eyes adapt to the casts so we don't realize they are there. These are best recorded in towns and cities at night, when the average street scene will contain an amazing mixture of light sources, each creating their own colors.

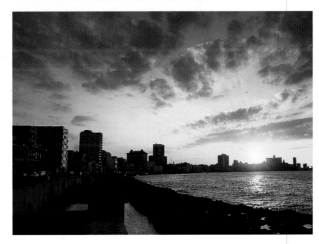

101 Sunrise and sunset

The light is at its most magical at dawn and dusk. Before sunrise and after sunset clouds are often uplit by the sun, which is below the horizon, so the sky is full of beautiful colors. When the sun is close to the horizon, golden light rakes across the landscape and casts long, cool shadows that reveal texture and form.

102 Making bluebells blue

It is notoriously difficult to photograph bluebells and make their color reproduce accurately. One solution is to use an inverted pale blue graduated filter to cover the bottom part of the picture area where the flowers are. Results are also better in overcast weather when the light is soft. Finally, careful adjustments in Photoshop using Color Balance or the Hue/Saturation slider may help.

104 Correcting color casts

You can use filters and Photoshop controls to get rid of unusual color casts, but don't be too eager to do so–often their strange and vibrant colors can improve a photograph, as you'll discover when shooting the urban landscape at night.

105 Adjusting white balance

Instead of always shooting with your digital camera set to AWB, experiment with different settings. Set Tungsten when shooting in daylight and your pictures will record with a cold, blue cast. Set Cloudy, and your pictures will appear warmer–great at sunrise and sunset.

Working in black and white

106 Why black and white?

Because it's moody, evocative, dramatic, nostalgic, atmospheric, artistic, simple, and stunning. We may live in a colorful world, but black and white strips our world down to its bare essentials of tone, texture, shape, and form.

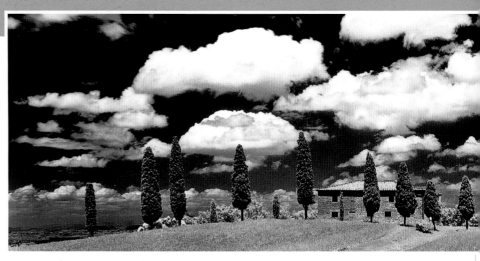

107 Learning to see in black and white

The key to successful black-and-white photography is in visualizing how a scene will record when stripped of its color; try to look beyond the color itself and focus on texture, form, shape, and tone. These will become the key elements that make or break the final image.

108 How colors translate

It's important to understand how colors translate to gray tones as this can influence the tonal relationships in the final photograph. Red and green record as a similar gray tone, for example, so if red and green are the dominant colors in a scene, the final black-and-white image will look rather flat.

109 Exposing for black and white

Expose for the shadows and let the highlights take care of themselves—the opposite of how you expose for color-slide (transparency) film. This is because you need to ensure that shadow detail records on the negative.

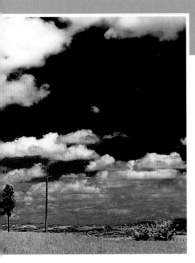

110 Using colored filters

Color filters can be used to alter the contrast and tonal balance of a black-and-white photograph. Red, orange, green, and yellow are the most popular colors. In each case, the filter lightens its own color and darkens its complimentary color.

Filter color	Effect
Yellow	Slightly darkens blue sky so white clouds stand out. Lightens skin tones and helps to hide skin blemishes. Ideal for general use, although the effect is quite subtle.
Orange	Noticeable darkening of blue and stormy skies, so adds drama. Also helps to reduce haze, hide freckles in portraits, and increases contrast. Good choice for landscape photography.
Green	Good separation of green tones makes this filter ideal for landscape and garden photography or shots of trees. It also darkens red.
Red	Blue sky goes almost black, clouds stand out starkly, and a dramatic increase in contrast allows you to create powerful pictures. Darkens greens considerably.

111 Dodging a print

If you want areas of a black-and-white print to come out lighter, a technique known as dodging can be used. This involves attaching a piece of card—the size and shape being dictated by the area to be dodged—to a length of fine wire and holding it over the print for part of the exposure so the area is "held back." By gently vibrating the dodger during exposure, its shape won't record on the final print.

112 Burning-in

This is the opposite of dodging. Areas of the print that come out too light are given more exposure so they become darker while the rest of the print is covered. If the area to be burned-in is small, a hole can be cut into a piece of card so that light is allowed to pass through it to the desired area of the print. If the area is big—the sky, for instance—then you can use a sheet of card or your hand to cover the rest of the print.

113 Are graduated filters necessary?

Although it's common to burn-in the sky when printing black-and-white photographs, you can still use a neutral-density (ND) graduated filter when taking the photograph to lower the contrast between the sky and land. This will make it easier to print the sky because less burning-in will be required. Use a 0.6 or 0.9ND grad.

114 Darken the corners

A good way to frame your main subject and direct the viewer's eye toward it is by artificially darkening the corners of the print to create a gentle vignette. Do this by burning-in each corner of the print for a few seconds—remember to keep the mask moving during exposure so the vignette has a soft edge.

115 Extreme contrast

Although most black-and-white negatives should print well using a contrast grade of II or III, you can produce amazing effects by working at harder grades, such as V, so shadows turn deep black and highlights shimmer. Use this technique on architectural and abstract shots to produce simple, bold images.

116 Go for grain

Photographers seem to have an obsession these days with producing pictures that are razor sharp and grain free, but in a black-and-white image coarse grain can add texture and drama to a print, so don't be afraid to use fast films, uprate, and push-process films to increase the grain—or add grain to digital images in Photoshop.

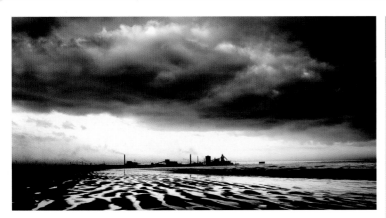

117 Increasing the drama

One of the great things about black-and-white printing is that the final print you produce doesn't have to bear any resemblance to how the original scene appeared—so don't be afraid to use your imagination and skills to turn the ordinary into the extraordinary.

118 Softly softly

You can produce wonderful dreamy effects by printing black-and-white photographs through a soft-focus filter. The filter is placed beneath the lens so the negative is projected through it onto the printing paper during exposure. Vary the effect with filters of different strength, or make your own by smearing Vaseline onto a piece of clear glass or plastic.

119 Add texture

If you lay a large sheet of wax paper over the unexposed printing paper on your enlarger baseboard, then contact the two materials with a sheet of clean glass; when you expose the printing paper the texture of the greaseproof will record on the final print, as shown below.

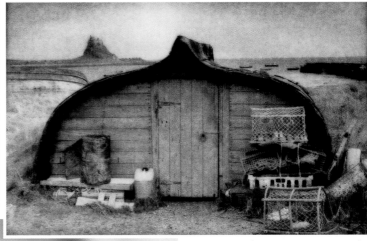

120 Carry two cameras

If you shoot digitally, color images can easily be converted to black and white. However, if you still work with film, ideally you should carry two camera bodies—one loaded with color film and the other loaded with black and white.

Perspective and scale

Photography may be a two-dimensional medium, but, if you want to produce pictures with impact, you need to find ways of adding depth.

121 What is perspective?

Perspective is the impression of depth that is created by the spatial relationship between the elements in a scene. Our brain looks for clues to establish which elements are close and which are farther away. By using the same clues when composing a photograph you can create the illusion of three dimensions, even though the photograph only has two.

122 Lenses and perspective

Although perspective doesn't actually change, the type of lens you use will give the impression that it does. Wide-angle lenses make the elements in a scene seem more widely spaced, while telephoto lenses appear to crowd them together. However, in reality perspective remains the same. To prove this, take one photograph with your zoom lens set to, say, 28mm, then a second of the same scene from exactly the same position with the zoom set to 200mm. If you crop a section of the wide-angle view so it shows the same area as that captured in the telephoto view and compare the two, you will see that perspective in both images is identical. Perspective only changes if you also change camera position.

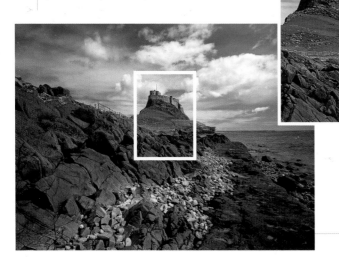

123 Aerial perspective

Haze, mist, and fog may at first seem to reduce any sense of depth, but if you look carefully you will see that the layers in a scene become lighter in color or tone as distance increases. This is known as aerial perspective, and it's best captured using a telephoto or telezoom lens to fill the frame with a more distant part of the scene where the effect is stronger.

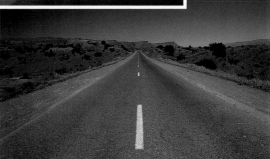

124 Linear perspective

If you include parallel lines in a photograph—such as the edges of a long, straight road, or rows of crops in a field—you will see that those lines appear to move closer together with distance. This is linear perspective. In reality the lines remain the same distance apart no matter how far away they are, but because they appear to be closer together, our brain tells us they must be moving away from the camera so distance and depth is implied. A wide-angle lens is the best tool for revealing this, and ideally you should include the vanishing point—the imaginary point in the distance where the lines appear to meet.

125 Diminishing perspective

If you photograph an avenue of trees, all roughly the same height, the tree closest to the camera will appear slightly bigger than the one next to it, and so on until the last tree appears to be a fraction the size of the first. This is diminishing perspective, or diminishing scale. Our brain tells us that the trees are all a similar size, so if one appears smaller than another it must be farther away from the camera, and a sense of depth is achieved.

126 Stretching perspective

Wide-angle lenses appear to stretch perspective by making the elements in a scene seem more widely spaced, and in doing so they create a strong sense of diminishing scale. If you move in close to a haystack in the foreground of a scene, for example, it will appear much bigger than the farmhouse in the distance—which means the house must be much farther away. This is one of the most effective ways of creating a sense of depth in a photograph.

127 Size recognition

A simple way of implying scale in a photograph is by including something of consistent and recognizable size, so the viewer can make a comparison between it and other elements that appear in the same scene. For example, if a person appears dwarfed by a waterfall, we know the waterfall must be huge.

128 Unreal scale

Scale doesn't always have to be accurate or realistic, and by intentionally breaking the rules you can create images that jolt the senses and force the viewer to take a second look. A classic example of this is the thousands of pictures taken each year of tourists appearing to hold up the Leaning Tower of Pisa with one hand—a trick created by a clever use of camera angle that makes the impossible seem possible.

129 Compressing perspective

If you photograph a scene using a telephoto lens, the elements you include will appear to be crowded together, and this can produce very simple, powerful images—think of a distant mountain range or the congested buildings in a busy city. The greater the focal length, the more pronounced this effect.

130 Creating scale

If no sense of scale appears in a scene, create your own by including a recognizable feature, such as a person or vehicle.

131 Look for patterns

Repetition makes for interesting pictures, so keep an eye out for patterns—natural or manmade—and crop out unwanted information to keep the composition simple and striking.

132 Flat light

In dull, overcast weather the light is very low in contrast so there are no discernible shadows and the world looks rather flat and two-dimensional. However, this can produce very atmospheric images—especially in black and white.

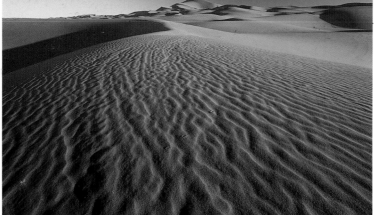

134 Eliminating scale

Excluding all clues about size and scale can produce successful photographs because they captivate the viewer and force them to try to work out just what it is they're looking at—which means their attention and interest is held.

133 Side lighting

Side lighting is very effective in revealing depth because the shadows are clearly visible, and they help to accentuate texture and modeling. Think of a landscape photographed in early-morning light with the sun at 90 degrees to the camera or a portrait where your subject is lit from one side—the play of light and shade is highly effective in implying depth.

136 Put yourself in the picture

If you can't find anything to suggest scale in a scene, use yourself–compose the shot, set the self-timer, then dash into the foreground. Wearing a red jacket or holding a red umbrella will ensure you stand out and also create a strong focal point.

137 Shooting silhouettes

Despite being clearly two dimensional, silhouettes can create great images because they're so simple and striking. The main factor you have to bear in mind is that the subject you shoot forms an easily recognizable shape, otherwise you'll end up with a confusing muddle of overlapping black shapes.

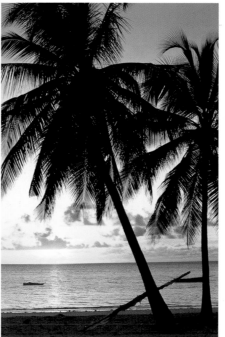

138 Go for balance

A balanced composition is easier to look at and enjoy, so when using perspective and scale to give your pictures depth, remember also to work carefully with the elements in front of you, so the final photograph is ordered and harmonious.

135 Foreground interest

Including bold foreground interest in a composition is a great way to capture a strong sense of depth and scale, so always be on the lookout for suitable features when shooting landscapes.

Lines and shapes

Whether they're natural or manmade, assumed or real, lines and shapes are powerful compositional aids that can make a good picture great.

139 Leading the eye

Your aim when composing a photograph is to lead the viewer's eye into the picture and to take it on a compelling journey around the scene you're depicting. Lines in their many forms can be used to do this, and they often add a sense of depth and scale at the same time.

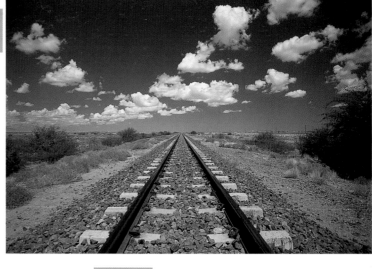

140 Horizontal lines

Horizontal lines echo the horizon, so are naturally passive and suggest repose. Manmade boundaries in the landscape–such as walls and fences–are obvious examples of horizontal lines that help to divide the image up into definite areas. The eye begins at the bottom of a picture and works up, so horizontal lines divide it into sections that can be observed one at a time.

141 Vertical lines

Vertical lines are more active, and they create tension in a composition–think of the lines created by electricity pylons or the soaring walls of skyscrapers. To maximize the effect, turn your camera on its side so the eye has further to travel from the bottom of the frame to the top.

142 Converging lines

Converging lines are the most powerful of all because they add a strong sense of depth to a photograph and carry the eye through the composition from foreground to background. The converging effect is best emphasized using a wide-angle lens–28mm, 24mm, or 20mm–so the lines appear wide apart in the foreground then move closer together with distance until they meet at the vanishing point.

143 Diagonal lines

Diagonal lines contrast strongly with the horizontal and vertical lines that form the borders of an image, so can create tense, dynamic compositions. As the eye tends to travel naturally from bottom left to top right, diagonal lines traveling in this direction also carry the eye through a scene from the foreground to the background.

144 The vanishing point

This is the imaginary point in a scene where converging lines appear to meet–include it so that the composition is brought to a satisfying conclusion.

145 Using shadows

Shadows of trees, people, buildings, telegraph poles, fences, and many other features can be used as lines in a composition. For the best results, shoot when the sun is low in the sky—early or late in the day—so shadows are long, and adjust the camera position so the shadows form horizontal, diagonal, or vertical lead-in lines. Shadows also form interesting shapes in their own right and can help you to create striking images from literally nothing.

146 Manmade lines

There are many examples of manmade lines—walls, fences, hedgerows, avenues of trees, furrows and planted crops, pathways, and roads, to name just a few.

147 Natural lines

Rivers and streams are the most common natural lines in the landscape. Use them to lead the eye into the scene.

148 Treemendous

Fill the frame with the regimented trunks of trees to create simple, dynamic compositions. Turn the camera on its side to make the most of the vertical lines created by the trunks and use a telephoto lens to compress perspective.

149 Look for spirals

Look for subjects where the focal point is central, but the eye is then encouraged to spiral out to the edges—such as close-ups of flowers. You can also create this effect by zooming your lens during exposure (see tip 487).

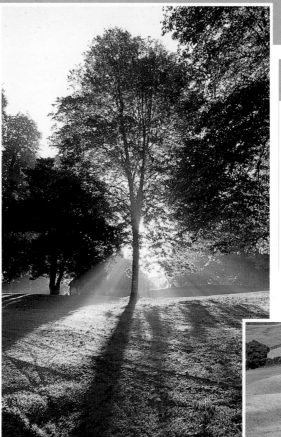

150 "S" shapes

The curving "S" created by a meandering river or stream forms a perfect lead-in line, but is much more soothing and gentle than a straight line.

151 Triangles add strength

The triangle is the strongest shape, so if you can arrange the elements in a scene to form one, this will add strength to the composition. For example, three people arranged in a portrait so their heads form a triangle will produce a stronger composition than if you simply line them up. Make sure the triangle has the point at the top, otherwise imbalance will result.

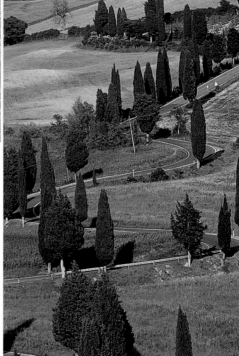

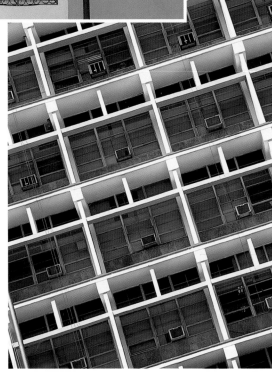

152 Repeat after me

Patterns hold the attention because the repetition of features encourages the eye to look around the frame, moving from one to the next.

153 Assumed lines

Lines can be assumed as well as real. If you photograph a person looking into a scene, for example, an assumed line will be created by the direction of their gaze, simply because we can't help but follow it to see what they're looking at.

154 Symmetry and asymmetry

Photographs that are composed symmetrically appear balanced and stable and are restful to look at. However, if you want to create tension and make your pictures dynamic, go for an asymmetrical composition instead.

155 Abstract eye

A composition doesn't have to be realistic or make sense to be successful, so experiment with using shapes, lines, and colors in a more abstract way, and try to exclude all references to perspective, scale, or reality.

156 Camera angle

You can change the way lines work in a picture by adjusting the camera angle. Tilt the camera left or right, for example, and horizontal or vertical lines become diagonals that are more dynamic. Try this when shooting modern architecture.

157 Using your lenses

The inherent characteristics of wide-angle and telephoto lenses will help you to make the most of lines and shapes in a scene.

158 Designing the image

In still-life photography you have the benefit of being able to decide exactly what appears in the composition, so you can start with a blank canvas and design your own pictures.

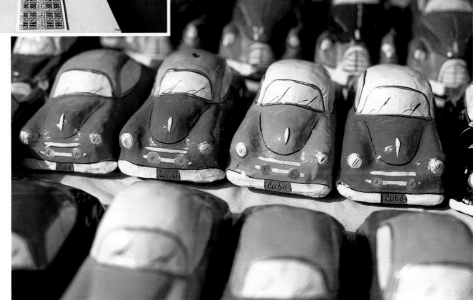

159 Creating lines

If there are no obvious lines to lead your eye into the scene, create some. On a beach or in a desert, simply walk into the scene and leave a line of footprints that start in the foreground and stretch into the distance.

160 Develop your eye

The best way to improve your eye for a picture is simply by taking pictures, as many as you can, at every opportunity. Learn to overcome familiarity and see pictures in all situations.

161 Keep it tight

Windy compositions tend to be boring compositions, so get into the habit of excluding unwanted information when you compose a shot and get close to your subject.

162 Juxtaposing shapes

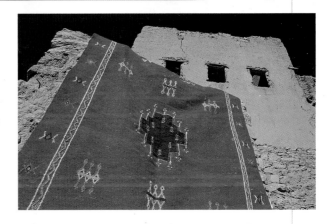

Use lens choice and viewpoint to change the relationship between the elements in a scene. Wide-angle lenses are especially useful because only a slight change of position can transform the composition due to the way they stretch perspective. The urban landscape is a great place to use this trick, as bold shapes and strong colors abound.

Framing your subject

Whether they're natural or manmade, frames can be used to enhance a composition and direct the viewer's eye toward your main subject.

163 Why framing works

Framing a scene works in the same way as framing a photograph–it adds a sympathetic border and draws attention toward the central area where the main interest is. Frames can also be used to hide distracting details and simplify compositions.

164 Overhanging trees

The most popular natural frame is created by the overhanging branches of trees–you can use them to frame the top of the picture like a canopy and direct the eye to the scene beyond. Branches will also help to cover up large areas of empty sky, and in doing so make the composition more interesting.

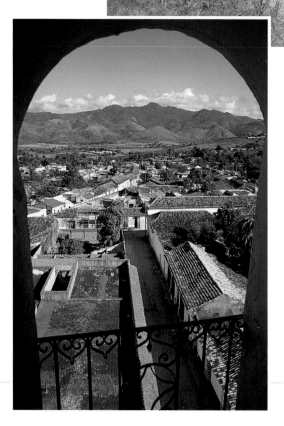

165 Doorways and windows

These both make great frames–either of the view from inside out, or from one room to the next when shooting interiors.

166 Natural frames

Natural frames are often found in woodland and hedgerows–just look for a gap that you can see through, then vary your distance from it to control the effective size of that gap and how much of the picture area is occupied by the frame.

167 Creating frames

If you move close enough to an object or element–the corner of a building, a wall, or a tree, for example–you can use it to help frame the scene beyond. It may not be a frame in the classic sense, but its effect on the composition will be the same.

168 Sharp or blurred?

If your frame is sharply focused it will become an integral part of the composition and demand attention. However, if you intentionally throw it out of focus by shooting at a wide aperture, the eye will tend naturally to look beyond it, so the scene you're framing will be more prominent.

170 Watch your exposure

You need to take care when shooting through frames that are dark and shady because they can fool your camera's metering system into overexposing the brighter scene beyond the frame. Avoid this by metering for the brighter part of the scene or walking beyond the frame to take a meter reading.

171 Simplicity counts

As with all aspects of composition, simplicity is the key. If you use a natural or manmade frame, make sure it isn't fussy or complicated, otherwise it will take attention away from your main subject and defeat the object!

169 Frames in silhouette

Frames are at their simplest and most effective when reduced to a silhouette. This is easy to achieve when the feature you are using as a frame is in shadow–such as an archway or tunnel–because, if you expose for the scene beyond it, the frame itself will be underexposed and come out black.

Viewpoint

There's more to taking great pictures than just finding the nearest viewpoint, raising the camera to your eye, and firing away.

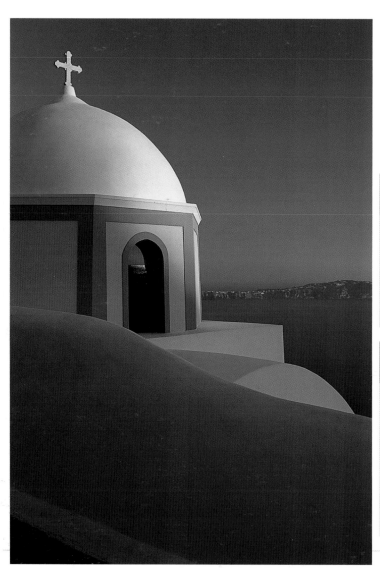

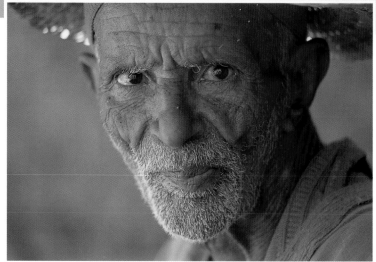

172 Do your homework

It pays to do a little research before visiting a new location so you have a basic idea of what to expect when you get there and can start planning your photography well in advance.

173 Filling the frame

One of the biggest compositional mistakes photographers make is not filling the frame, so get into the habit of asking yourself, "Is this composition tight enough?" If the answer is "No," take a few steps forward or change lenses.

174 Move closer

The closer you are to your subject, the more powerful the composition is likely to be because it excludes unwanted information and concentrates the viewer's attention. Go close to increase impact.

175 Shooting from eye level

Don't always take pictures with your camera held at eye level. It may be the most natural place to shoot from, but it's also the most predictable—so, if you want to capture the world in a more dynamic way, you need to get down low or climb up high.

178 Unusual angles

Experiment with unusual angles to give everyday subjects an interesting twist. Try tilting your camera over so that vertical lines lean—something wedding and fashion photographers often do to add impact to their pictures, although it works well with any subject because it forces the viewer to take a second look.

179 Use your feet

The most useful compositional aids at your disposal are your feet—use them to explore a subject from different angles and viewpoints. See what's around the next corner, over the next hill, or from the top of that tall building.

180 Kneeling down

You don't need to make excessive changes to camera position in order to transform a picture—even something as simple as kneeling down can make a big difference, as it lowers the camera and allows you to capture the world from a slightly different angle.

181 Find a high viewpoint

Shooting from the top of a tall building, bridge, or any large structure can produce stunning images—especially in busy cities where the buildings are congested and there's lots of activity at street level. Use a wide-angle lens to capture a broader view and give the impression that you were further off the ground than you really were.

176 Low viewpoints

A worm's-eye view of the world is always captivating because we're not used to seeing things from such a low vantage point. Try placing your camera on the ground and pointing up—this works great when shooting everything from people to flowers.

177 Make the most of your tripod

A tripod will allow you to set up your camera in unusual spots and keep it rock solid, so you won't need to worry about camera shake when using slow shutter speeds. Make the most of this facility and capture the world from alternative angles.

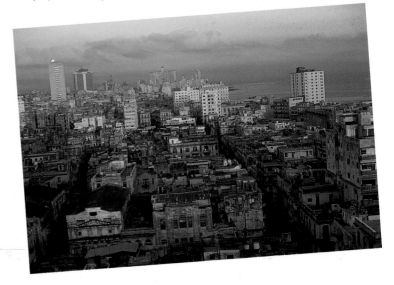

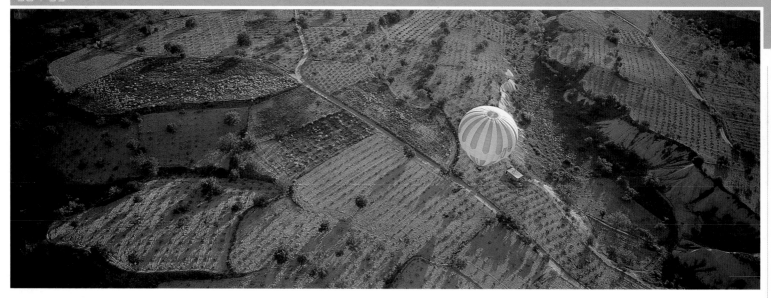

182 The earth from the air

For the ultimate in high viewpoints, nothing beats taking to the skies in an aircraft or hot-air balloon so you can capture the landscape stretching out below.

183 Shoot from ground level

If you don't mind getting grubby, try stretching out on your belly and shooting from ground level. You might receive a few strange looks in towns and cities, but the pictures will be great.

184 Take a chance

If you're feeling really brave, try taking pictures without even looking through the camera's viewfinder—hold the camera above your head or close to the ground and fire away. You'll be surprised by the results.

185 Check maps

Detailed maps can provide lots of useful information about a location and help you to identify possible viewpoints before you leave home—as well as other features, both natural and manmade, including rivers, high ground, buildings, and roads.

186 Explore your subject

When you arrive at a location, be prepared to spend some time exploring it. By all means take the shots that immediately spring to mind but when you've done that, go for a wander to see if you can find a better viewpoint. More often than not you will, and you'll produce pictures that are a break from the norm.

187 Time of day

Time of day will dictate your viewpoint, because the changing position of the sun during daylight hours will transform the mood of a scene as well as the quality and direction of the light falling on it.

188 Gaining height

If you need to shoot from a higher viewpoint, look for natural features that will increase your elevation—walls, trees, and balconies are ideal. The roof of your car can also be used—but take care not to damage it!

189 Carry a stepladder

Some landscape and architectural photographers carry stepladders in the trunks of their cars to raise camera position. This can make a big difference to the perspective you gain.

190 Try something different

If you want to produce original work, you'll need to think about ways of doing things differently from everyone else. This is especially true now the digital revolution is here, because it's easy to produce well-exposed and pin-sharp pictures—what sets a picture apart is the photographer and their imagination.

191 Get off the beaten track

If a well-worn track leads to a great view, that's because everyone goes there. However, there could be an even better view just a little way away, so always be prepared to deviate and find your own viewpoint.

192 Look up, look down

Photographers have a tendency to look at everything from eye level, but in the urban landscape the world above your head can be just as interesting, while out in the wild you will often find fascinating details literally at your feet.

193 Don't be lazy

"The harder you work, the luckier you get." This motto applies to everything, including photography—if you're a lazy shooter your pictures will never be more than average, but if you're willing to walk the extra mile, stay out a little longer, and make the effort to explore a location fully, you'll be rewarded with great shots.

194 Check the corners

Before tripping your camera's shutter to take a picture, always spend a few seconds checking the four corners of the viewfinder to make sure unwanted or distracting elements aren't creeping in. Any that do can always be cropped out later, but composing with the intention of printing an image full frame is a good discipline to adopt.

195 Shooting through glass

Shooting through windows can give you an unusual view of the world. Colored glass will tint the scene you see through it, while old windows tend to add distortion that can work well. Remember that windows also make great frames around the view.

196 Less is more

Whatever your subject, always remember that less is more. Cluttered compositions look untidy, are distracting, and fail to deliver a clear message, so strip away unwanted elements until you're down to the bare bones, and the final image will be much more powerful.

Compositional aids

Effective composition comes with time, patience, and experience, but there are also a few handy tricks you can use to give your eyes a helping hand.

197 The viewfinder

Looking through your camera's viewfinder so you can see what's going to appear in the final picture is the first step toward composition–but remember that few SLR viewfinders show 100 percent of the image area, so you may get more in the final picture than you expected.

198 The preview screen

One great benefit of digital capture is that seconds after taking a picture you can check it on the preview screen–as well as assessing exposure, you can also decide if you like the composition.

199 Cropping cards

If you make two "L" shapes from black card you can put them together to create rectangles, squares, or panoramics that can be used to help you visualize how best to compose a picture.

200 Use your fingers

Instead of cropping cards, use your fingers as a compositional aid. Extend your thumb and index finger on each hand to produce an "L," then put them together to create a rectangle that you can raise in front of your eyes.

201 Slide mounts

The card masks and mounts used to present color slides make handy compositional aids–just hold them in front of your eye to frame the scene.

202 How to estimate angle of view

To get a reasonable idea of what different lenses will see, vary the distance you hold your compositional aid away from your eye. The closer it is, the wider the angle of view; the further away, the smaller it is.

203 Viewing aids

The adjustable viewing scopes used by movie directors can also be used by photographers, as they're marked with lens focal length–use one to assess a scene and establish which lens will be the best one for the job.

204 The magnification tool

If you're not sure that a picture is pin sharp when you check it on your camera's preview screen, use the Zoom or Magnification control to blow up just a small part of the image so you can check for critical sharpness.

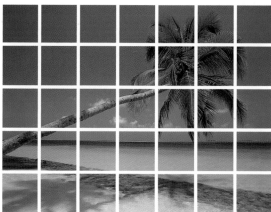

205 Interchangeable focusing screens

If your camera accepts interchangeable focusing screens, consider switching from a plain screen to a grid screen—grids are ideal for helping you to compose photographs and to make sure everything is square.

206 Using a tripod

A tripod makes a great compositional aid because it fixes the position of the camera and allows you to make small adjustments to the composition until it's perfect. Tripods also slow down your work and make you think more about each shot, which leads to better composition.

207 The brighter the better

Bright viewfinders make composition easier simply because you can see everything more clearly. Lenses with a fast maximum aperture, such as f/2.8, are a great help.

208 Keep it level

A small spirit level attached to your camera's hotshoe will help ensure it's perfectly square—so the horizon will be level and converging verticals avoided.

209 Your tripod head

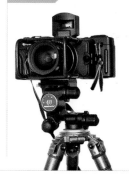

Ball heads are quick and easy to use, but tripod heads with geared controls are better for making small adjustments to composition.

210 Leveling bases

If you intend shooting sequences of images to stitch together into panoramas, consider investing in a leveling base, which will allow you to get the camera perfectly level through 360 degrees even if the tripod itself isn't level.

Break The Rules

Producing original images

"To consult the rules of composition before taking a photograph is like consulting the laws of gravity before going for a walk." So said the late, great photographer Edward Weston—and he was right!

211 Rules are made to be broken

Learn the rules of composition, practice, and perfect them—but never be afraid to break them. You shouldn't compose every photograph you take to a formula, and if you were to try to, your work would quickly become predictable.

212 Horizon across the center

Start by putting the horizon across the center of the picture. Doing so produces images that are balanced and soothing to look at—perfect for tranquil landscapes, especially when you're capturing a reflection in calm water.

213 Put your main subject in the middle

If you want to create dynamic images, this is the last thing you'll want to do—but sometimes images that speak in a whisper are preferable to those that scream for attention.

214 Close to the edge

Create tension and discord by placing your main subject right at the edge of the picture. It's not what the viewer expects, so it grabs their attention—especially when the rest of the frame is empty space.

215 Jar the senses

Use clashing colors and unusual camera angles to create compositions that jar the senses. Start out composing conventionally, then do everything you can to change that.

216 Creating tension

When we look at a photograph, our reaction to it is based on a lifetime's experiences and memories that shape our visual awareness and emotional state. However, if you present an image in such a way that the viewer has nothing to compare it with, tension is created because they're not quite sure what's being said or how they should react.

217 Wide angles for portraiture

Wide-angle lenses stretch perspective. Use one really close to shoot portraits and the results will be anything but flattering because your subject's facial features will be distorted—we're talking a long nose, bulging eyes, and a big mouth!

218 Shoot from unusual angles

We're used to seeing the world from a height of between 5 and 6ft (1.5-2m) off the ground, and that tends to be where most of our photographs are taken from—eye level. However, by intentionally avoiding this viewpoint and capturing familiar subjects from unusual angles, more interesting pictures will result.

219 Cut off part of your subject

If you want to create images full of intrigue, try cutting off an important part of your subject. When shooting portraits, for example, only include half the person's face—or even cut off their head altogether, so the viewer is left to wonder what they look like.

220 Obscure subjects

One way to take the viewer by surprise is by photographing things that would normally be ignored—graffiti, telephone kiosks, shop signs, trash, broken benches, etc. The more obscure the better!

221 Tilting the camera

We normally try to take pictures with the camera perfectly level, but if you deliberately tilt it to an extreme angle the effect on a composition can be amazing—so try it.

222 What is it?

Try taking pictures in such a way that the viewer doesn't really know what they're looking at. Move in close, shoot with the subject out of focus, or add blur by moving the camera during exposure.

223 Creative snapshots

Exercise your creativity: get into the habit of carrying a compact camera everywhere so you can grab pictures whenever and wherever of anything that catches your eye.

224 Let technique take over

If all you can see in a photograph is technique then it is often said to be a failure. But don't let that stop you experimenting and innovating. Use the Hue/Saturation function in Photoshop to transform an image; create infrared effects; convert parts of the image to black and white but leave the rest in color—let your imagination run riot!

225 Taking risks

The most exciting and successful photographers are the ones who take risks and try something different. Are you a risk taker?

226 Just add words

It's often said that a great photograph needs no words to describe it. Nevertheless, adding words can take your work to another creative level and allow you to influence the viewer's response to it. So why not come up with unusual titles or add lines of poetry to images?

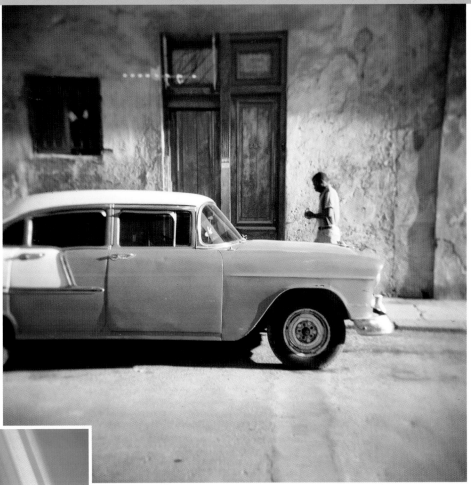

227 Find your creative voice

It's easy to follow fashions and styles in photography, but in this digital age you need to work doubly hard if your images are to be a break from the norm. Forget about perfection and convention and do your own thing: toy cameras, pinhole, Polaroid—there are endless options.

In-camera Composition

Getting it right in-camera
Although it is now possible to transform an image on your computer, you should always strive to compose your picture when you take it rather than relying on technology later.

Landscapes

The landscape is perhaps the most popular and accessible photographic subject—but that doesn't necessarily make it the easy option.

228 Telling a story

When you compose a landscape picture, think of it as a visual story that has a beginning to draw the viewer in, a middle that holds their attention, and an end to bring the story to a satisfying conclusion.

229 Right place, right time

Being in the right place at the right time is a crucial factor in capturing the landscape at its best, so be prepared to work hard, accept failure, and keep going back until you get the picture.

230 The early bird

Oh, and be prepared to set your alarm nice and early. The best shots are often taken in the period from 30 minutes before sunrise to an hour after, because that's when the light is at its most magical and the landscape is full of atmosphere.

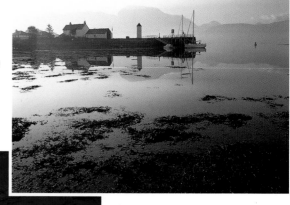

231 Fill the foreground

Strong landscapes almost always have a strong foreground to draw the viewer in and give the composition a sense of perspective and scale—so always look out for foreground interest when exploring a location.

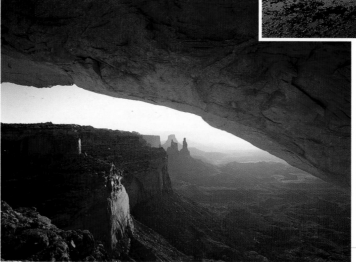

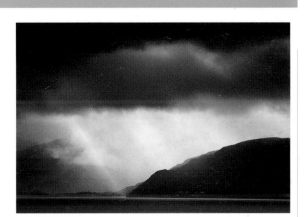

232 The intimate landscape

Landscape photographs don't always have to be of sweeping views–small details such as ripples on a sandy beach or the colors and textures in rocks can be just as interesting.

233 Revealing depth

Photographs are flat, as they only have two dimensions. However, by clever use of perspective and scale, you can imply a strong sense of depth and give the illusion of three dimensions. Wide-angle lenses are the ideal tools for this as they stretch perspective.

234 Recording texture

Use side lighting from the sun to reveal texture. Early morning and evening are prime times because the sun is low in the sky and raking light will pick out the most delicate textures, even things as small as insect tracks in sand.

235 Black-and-white weather

Don't see dull days as unsuitable for photography–just think of them as black and white days!

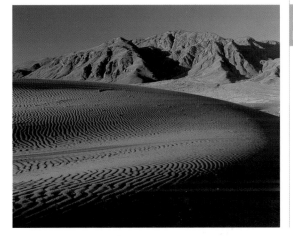

236 Check the weather forecast

If you're planning a long trip or a really early start, it's always worth checking the long-term weather forecast for the area you intend to visit–just search the internet for a list of local websites. That said, don't be afraid to chance your arm–"bad" weather can produce amazing landscapes.

237 Get to know a location

Initial visits to a location often result in unoriginal pictures, but if you keep going back you will get to know the area more intimately and see beyond the obvious. Go back at different times of day, different seasons, and in a variety of weather conditions.

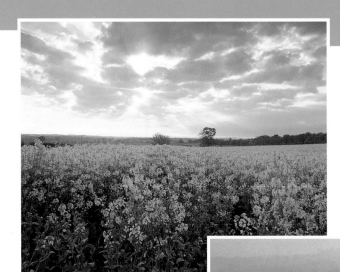

238 On your doorstep

There's a lot to be said for exploring your own backyard, wherever you live, you're sure to find interesting locations close to home that you can get to at short notice when the light's good, instead of having to plan trips in advance and travel long distances.

239 Use a tripod

They're a hassle to carry around, but a tripod is vital for successful landscape photography, allowing you to fine-tune a composition, leave the camera in position while waiting for the light to improve, and to keep the camera steady so you can use long exposure in low light.

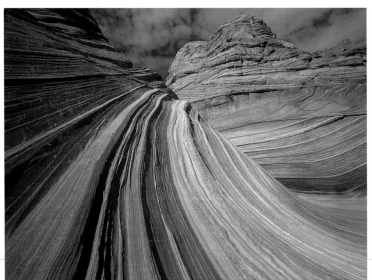

240 Quality of light

The quality of light is the one thing that can make or break a great color landscape. It doesn't matter how amazing the scene is or how dramatic your composition, if the light's flat and drab then your photographs will be too.

241 Warm light

Early and late in the day when the sun is low in the sky, the light has a beautiful natural warmth that brings the landscape to life and produces images full of atmosphere and good feeling.

242 | Cold light

In stormy, cold, or misty weather, the light has a natural coolness to it that adds an eerie, mysterious feel to landscapes. This is most pronounced when shooting in the shade where the light is even cooler. Also, try using long exposures at twilight to create cool images.

243 | Soft light

Soft light is ideal for revealing fine detail and tone in the landscape, because contrast is very low and there are no hard shadows or shimmering highlights to deal with. Cloudy weather produces this kind of light, or stepping into the shade when the sun is shining. Predawn and after sunset the light is also soft and atmospheric.

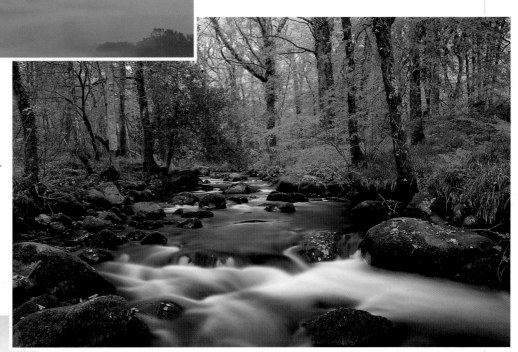

244 | Hard light

Direct sunlight is hard and harsh, casting strong shadows and creating bright highlights. The higher the sun is in the sky, the harder the light—so high summer sees the light at its hardest. While unsuitable for general landscape photography, such conditions can be effective for more abstract images.

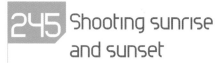

245 Shooting sunrise and sunset

Sunrise and sunset are prime times for landscape photography—especially near water, which reflects the warmth of the sun and sky. Use your longest telephoto or zoom lens to enlarge the sun's orb—taking precautions if the sun is bright to protect your eyes—and silhouette bold shapes such as boats, trees, and buildings.

247 Rainbows

Rainbows are formed when the sun shines through falling rain, adding a welcome splash of color to otherwise dark, brooding landscapes. Turn your back to the sun in such conditions to check for one.

248 Mist and fog

Mist and fog reduce the landscape to a series of soft tones and two-dimensional shapes. Emphasize the effect using a telephoto or zoom lens and concentrate on cold features such as trees or buildings. River views also look beautiful in misty weather—especially at sunrise, when the warmth of the sun slowly burns the mist away.

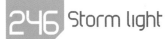

246 Storm light

The most dramatic conditions for landscape photography often occur when the sun breaks through a dark, stormy sky, so don't be too keen to head for cover at the first sign of bad weather. Stormy light is most likely on blustery days, when dark clouds are scudding across the sky and momentarily obscure the sun.

249 Marks of man

Don't be afraid to include evidence of man in your landscapes. Old walls, tracks, and hedgerows make great lead-in lines—as well as looking at home in the landscape. However, modern features such as wind turbines and electricity pylons can also produce dramatic images.

250 Lighting direction

The direction a scene is lit from by the sun will have a strong influence on the mood of the final image, so always give this some thought when composing landscapes.

251 From the side

With the sun off to one side of the camera, the landscape is side lit, so shadows fall across the scene and texture and form are revealed. This is the most effective lighting for landscapes, especially early or late in the day when the sun is low in the sky.

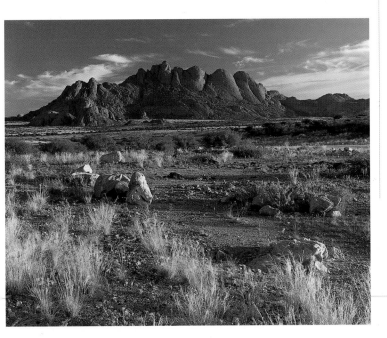

252 From the front

If you shoot with the sun to your back, the scene will be frontally lit so shadows fall away from the camera. Frontal lighting can be effective, especially when the light is warm, but the resulting photographs can look rather flat.

253 Back to front

Shooting into the light, or contre-jour, produces striking results. In strong light, bold features in the scene will record as silhouettes—a handy technique at sunrise and sunset—while in stormy weather you can capture amazing cloudburst effects. Shadows rush toward the camera, which can look stunning when shooting woodland scenes. Watch for flare, and be aware that underexposure is likely.

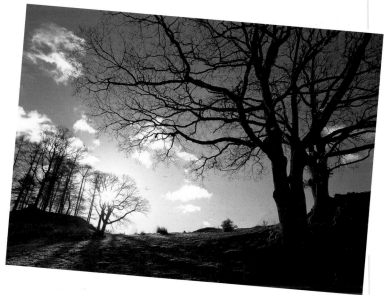

254 Rivers and streams

Rivers and streams make great lead-in lines that help carry the eye through a composition. On misty mornings they look incredibly atmospheric and at sunrise and sunset will mirror the fiery colors in the sky.

255 Time it right

Although landscape photography is a slow and contemplative subject, there can still be a "decisive moment" when all the elements in a scene come together, so don't get too laid back, or you might miss it.

256 Include reflections

Reflections add an extra dimension to landscapes, so on calm days head for flat water. Fill the foreground of your pictures with a reflection of the scene beyond, or use a telezoom lens to concentrate on parts of the reflection to create striking abstract images.

257 Shadowplay

Shadows not only help to reveal texture and form in the landscape but they can also be a useful compositional aid. For example, when the sun is low in the sky, use the shadows of trees as lead-in lines, and hide your own shadow by standing in the shadow of a tree.

258 Shooting in snow

Snow tends to fool camera meters into underexposure, so be prepared to dial in anything from +1 to +2 stops to compensate.

259 The harder you work

You can't take great landscapes from the comfort of your armchair, so get out there into the great outdoors, put your best foot forward, and explore.

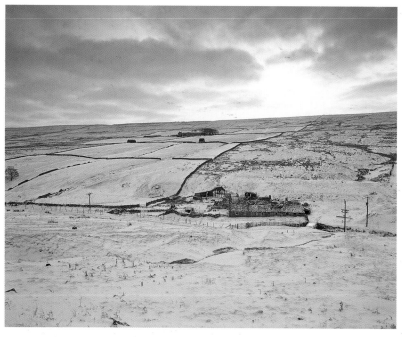

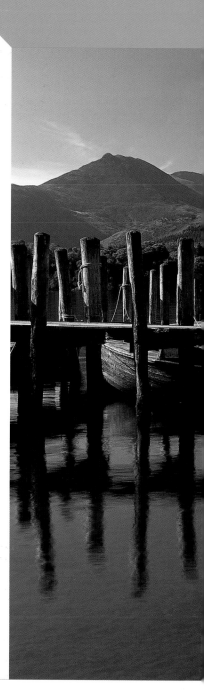

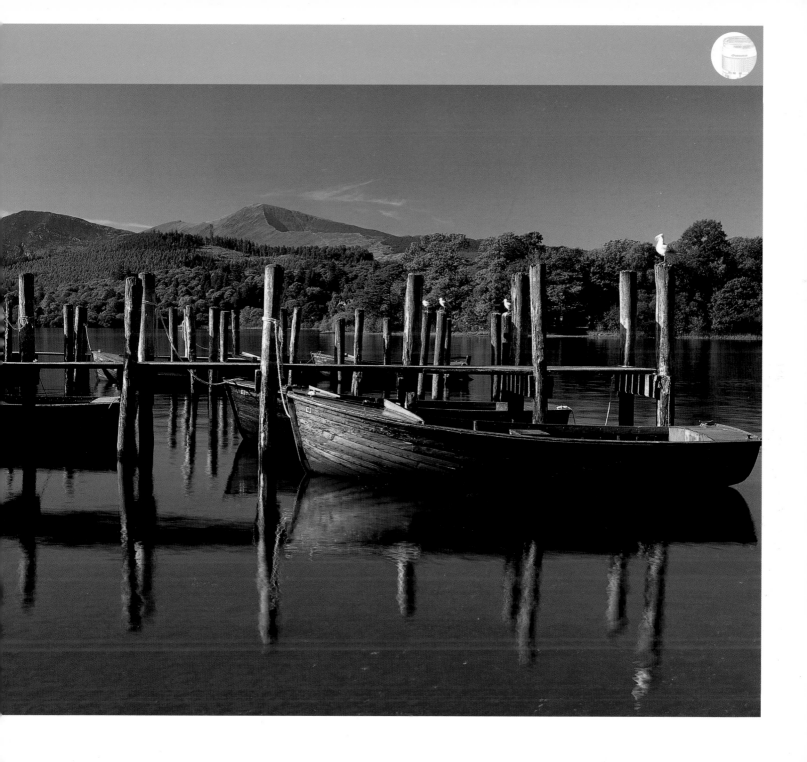

Architecture and the urban landscape

Big, small, old, new, grand, modest, traditional, cutting edge–buildings come in all shapes and forms, and all make great photographic subjects.

260 Verticals

If you photograph a tall building from close range with a wide-angle lens you will have no option but to tilt the camera back to get the top of the building in-frame. This results in converging verticals, where the sides of the building lean inward, and the building appears to be toppling over.

261 Avoiding converging verticals

The easiest way to avoid converging verticals is to keep your camera back square to the subject building–any unwanted foreground can be cropped out later. Other options are to back away and use a longer lens, or shoot from a slightly higher vantage point, a wall or a stepladder, for example.

262 Correcting converging verticals in-camera

A shift lens, also known as a Perspective Control (PC) lens, is designed to avoid converging verticals by allowing you to adjust the front elements of the lens so you can include the top of a building while keeping the camera back square. With large-format cameras, set up the camera square then apply rising front to include the top of the building.

263 Correcting converging verticals digitally

- Open the image in Photoshop.
- Go to Select>All.
- Go to View>Show>Grid to place a line grid over the image.
- Select Edit>Transform>Distort.
- Click on the top-left cursor and drag it slowly out to the left to straighten the wall, using the grid as a guide.
- Repeat for the top-right cursor then hit the return key.
- Select View>Show>Grid and uncheck the grid.
- If the image now looks a little squat, select Image>Image Size, uncheck the Constrain Proportions box, and increase the height of the image by between 5 and 10 percent.

264 Exploit converging verticals

Of course, you don't have to get rid of converging verticals–instead, why not make a feature of the effect by shooting buildings from ground level with your widest lens?

265 Time of day

A building's aspect will influence the best time of day to photograph it, so use a compass to establish which way it faces and time your shoot accordingly.

266 Shooting skylines

Cities often look their best when captured from a distance, as you can capture their true grandeur without the traffic, crowds, and congestion. Views across water are especially effective because the skyline will be reflected.

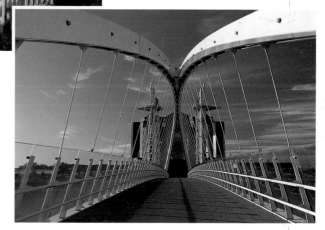

267 Twilight zone

Twilight is often the best time to shoot towering modern architecture because the sky acts like a huge diffuser, softening the light so contrast is low while the pastel colors in the sky are mirrored by any reflective surfaces in the building.

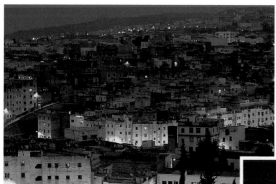

269 Reflected glory

You can take great shots of buildings reflected in other nearby buildings–industrial estates and business parks are great places to do this, as modern buildings with huge windows are constructed close together. Make sure the sun is shining on the building caught in the reflection.

270 Perfect symmetry

Symmetry makes for eye-catching compositions, so keep a look out for examples when exploring the urban landscape. Many modern buildings are highly symmetrical in their designs, while reflections can create symmetry by mirroring architectural features.

268 Exterior details

Use a telezoom lens to isolate interesting architectural details–old buildings such as cathedrals and castles can be great sources of such elements.

271 Go for graphics

Modern buildings tend to be very graphic, making use of bold shapes, strong lines, hard edges, and repetition. In bright sunlight against blue sky these features make perfect abstract images.

272 Early riser

By 8am most big towns and cities are already bustling with traffic and people, so if you want to avoid the noise and crowds make sure you're on location at first light when the streets are empty.

273 Night views

The urban landscape is often at its most stunning once the sun sets, light levels fade, and manmade illumination takes over. The best time to shoot night scenes is while there is still color in the sky, as this will provide an attractive backdrop while details will still be visible in the shadows.

274 Unusual reflections

Towns and cities are full of unusual reflections–in polished surfaces, wet paintwork, puddles, pools–so instead of just shooting an interesting subject or scene, capture a reflection of it instead to give your pictures a novel twist.

275 Contrast old with new

Towns and cities evolve over the centuries, so changes in architectural trends through the ages can often be seen side by side. This contrast of the old and the new can result in fascinating photographs–for example, an ancient stone church reflecting in the glass panels of a modern office block.

276 Window on the world

Windows make a great subject in their own right. You can use them to frame the view outside or capture reflections, while the rich colors in stained glass can be the source of stunning shots.

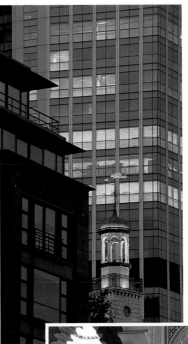

277 Heavy industry

Bridges, cranes, and other examples of heavy industry make great subjects–especially at night when they're often illuminated by colorful floodlights, or when captured in silhouette against the rising or setting sun.

278 Inside jobs

Buildings are often more interesting inside than out–especially older buildings–so don't forget to take a look inside when you've finished shooting the exterior.

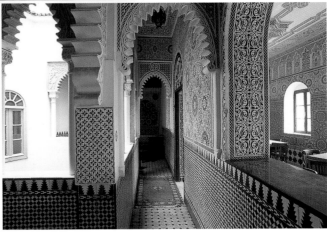

279 Sign of the times

Our towns and cities are full of signs that make great subjects. Neon signs outside bars and clubs are best photographed at night, while colorful road signs look great in strong sunlight captured against blue sky. Move in close to photograph parts of the sign and create striking abstract images.

280 Numbers game

Numbers make a great photographic theme, and towns and cities are full of them—on doors, painted on walls, printed on vehicles. Why not shoot a set of images of the numbers one to 100 and see how many different styles and designs you can find?

281 Alternative angles

Turn everyday urban subjects into stunning images by shooting them from unusual angles. For example, look skyward while standing beneath an electricity pylon, or look down from the top of a spiral staircase.

282 Down your street

You don't have to go far to discover interesting urban subjects—a stroll down your own street will reveal all kinds of things, from architectural details to graffiti. It's not what you shoot, but how you shoot it, and, if you can overcome familiarity, your own neighborhood can be hugely inspiring.

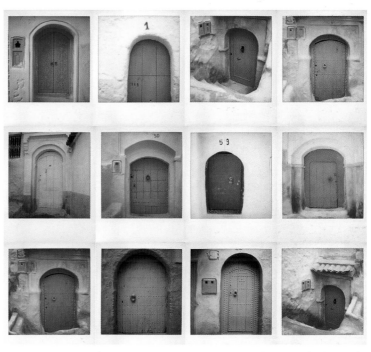

283 Create an architectural montage

You will have seen posters for sale showing local architectural details—doors and windows are popular as they vary so much. Why not work on a similar project yourself then combine the images in Photoshop to create a montage?

284 Photographing markets

Markets are great haunts for photographers. There are endless candid opportunities, of market traders as well as the general public, and markets are packed with interesting colors, details, and patterns.

Portraiture

We all shoot pictures of people, but how many of them could be regarded as true portraits?

285 Lenses for portraits

The ideal lens for traditional head-and-shoulders portraits is said to be a short telephoto of around 100 to 105mm, as this will compress perspective a little, which flatters facial features.

286 Capturing character

The aim of portraiture is to try to capture the character of your sitter. Sounds easy, but to do it well you need patience and the ability to communicate with your subject so they reveal their true self to the camera.

287 Filling the frame

In a portrait the subject should generally take center stage. Make sure they do that by filling the frame and excluding unwanted details that will only serve to distract the viewer.

288 Where should the eyes be?

It's tempting to put a person's eyes in the middle of the picture, but the composition will look more balanced and interesting if they're roughly a third of the way down from the top of the frame.

289 Keep backgrounds simple

Fancy, fussy backgrounds should be avoided at all cost—a plain white or black backdrop is all you need. Check out David Bailey's work if you're not convinced.

290 Adding catch lights

Catch lights help to put a sparkle in your subject's eyes. You can create them using fill-in flash when shooting outdoors or by holding a reflector near the camera. In the studio, brollies or softboxes fitted over the lights will create perfect catch lights.

291 Revealing texture

The best way to reveal texture in a person's skin is by lighting them from the side so one half of the face is lit and the other half thrown into shadow. This is great for character portraits but isn't particularly flattering!

292 Hiding skin blemishes

To hide spots, wrinkles, and other skin blemishes, avoid side lighting and instead flood your subject's face with soft light so there are no visible shadows. Overcast weather or open shade is ideal as the light will be soft. Reflectors can also be used to bounce light into the shadows.

293 Flattery will get you everywhere

Many people hate being photographed, so the least you can do is try and make them look good!

- Hide bald patches in men by shooting from a slightly lower position so the top of your subject's head can't be seen.
- Conceal double chins by shooting slightly higher then normal so your subject has to look up-this stretches the neck a little.
- Long noses are best tackled head on-side views merely make them appear longer.
- Avoid using lenses shorter than 100mm from close range as they exaggerate facial features.

294 Environmental portraits

Sometimes you may want to include your subject's surroundings in a photograph to reveal clues about who they are and what they do-a portrait of an artist will be more telling if you show them in their studio, surrounded by canvases and paints, for example.

295 Candid camera

Most people become guarded when they see a camera pointing at them, so the easiest way to capture natural expressions and true emotions is by shooting candidly to make sure your subject isn't aware of the camera.

296 People at work

Photographing people at work is a great way to shoot character portraits. We also tend to feel more relaxed in our natural environment-our comfort zone-so you stand a better chance of taking natural, revealing portraits. Why not take your camera to your own place of work and shoot a series of portraits of your colleagues?

297 Poser's guide

Professional models know exactly how to strike a pose that makes them look good. Unfortunately, the rest of us tend to turn into waxworks the minute a camera points at us, so you will need to give your subject some help if you want to take natural, relaxed portraits.

298 Subject standing

Standing poses can work, but only if your subject is confident. Help them along by suggesting that they put their hands in their pockets or rest one hand on a hip. Asking your subject to stand side on to the camera then turn their head to face it can also work.

299 Subject sitting

Asking your subject to sit down will immediately make them feel more relaxed. Also, we all have a certain way of sitting that helps to reveal our personalities.

300 Give them something to lean on

If sitting down isn't an option, look for something your subject can lean on—the edge of a table, a wall, anything that avoids a stiff, wooden pose.

301 Casual poses

Young people tend to be very image conscious and want to look good when photographed, so help them along with ideas for casual poses. Providing props that allow them to sit or lean will help.

302 Formal poses

For more formal, posed portraits, ask your subject to sit in a chair with their back straight. Instead of shooting head on, turn the chair 45 degrees then ask your subject to turn their head and face the camera.

307 The naked form

The most successful nudes express the beauty and purity of the human body, exploring the play of light and shade on its gentle curves and contours. Photographs don't have to be revealing or explicit to achieve this—in fact, often those images that leave plenty to the imagination are the most effective.

308 Parts of the body

If you're not interested in the naked form or can't find a willing nude model, why not concentrate on parts of the body instead—hands, for example, can be a fascinating subject because they tell us so much about a person.

303 Hands cupping face

A classic pose for a seated subject is to have them rest their face on cupped hands. It's a natural and relaxed pose, although make sure the sitter doesn't slouch and that the shape of their face isn't distorted.

305 Dynamic poses

If your subject is confident in front of the camera you can really go to town. Ask them to strike a sequence of unusual poses and fire away as they do so. Shooting from a low viewpoint or leaning the camera slightly to one side will also make the composition more dynamic.

304 Head resting on one hand

Alternatively, resting the head against one hand also looks attractive and comfortable as it's a pose we often adopt when relaxing.

306 Focus on the eyes

The eyes are said to be the windows of the soul, so always focus on your subject's eyes. If the end of the nose or the tips of the ears are out of focus it doesn't matter, but if the eyes aren't sharp then a portrait will fail because they are the first element we look at.

Still life

Whether you shoot things as they're found or build your own pictures, still-life photography can result in amazing images and test your skills to the limit.

309 Creating still lifes

Still-life photography may seem like a tough subject because you start off with a blank canvas rather than a full one, but this is what makes it challenging and rewarding—you're creating photographs from nothing.

310 Keep it simple

Simplicity is the key to great still-life photography. Just work with one or two items and see what you can produce.

311 Watch the background

The background you use can make or break a great still life, so think about what you use. Natural and textured materials will enhance natural objects, while simple, plain backgrounds such as paper or card are a better choice when you want your subject to take center stage.

312 Let it out

Don't be afraid to let some of the props in your still life break out of the edges of the frame—the composition will be more interesting than if you arrange everything neatly in the center.

313 Revealing texture

If you want to reveal texture in an object, light it from the side. You can do this with windowlight, but for more control try using a reading lamp or, better still, a slide projector, and adjust the white balance on your camera to get rid of any unwanted color cast from the light source.

317 Stick to a theme

Working to a theme can help to focus your ideas because it limits your range of subject matter, and often one picture naturally leads to another. The theme could be a color, a subject, a particular object—anything you like.

318 Found still lifes

If creating your own still lifes doesn't appeal, why not go in search of found still lifes instead and shoot things as you discover them. Old buildings, junk yards, greenhouses, beaches, and construction sites are great places to find interesting objects in situ.

314 Windowlight will do

You don't need fancy studio lights to produce successful still lifes—windowlight is perfectly adequate, and it can be controlled using reflectors, or modified with masks to reduce the amount of light, or softened with diffusing screens made from tracing paper or sheer material.

315 Using color

Color could be the basis of your still-life shots—then all you have to do is find suitable props. Go for contrasting colors—such as yellow/blue and green/red—or juxtapose objects to create color harmony by concentrating on warm hues, cold hues, or soft, muted colors.

316 Household objects

If you look around your home you'll find all kinds of subject matter for still lifes—collections of coins, medals, or old toys; plants and flower arrangements; cutlery; kids' toys; even small things like colored paperclips and thumbtacks. It's not what you shoot but how you shoot it.

Macro and close-up

Macro photography allows you to explore a whole new world—one that's often far more interesting than what we can see with the naked eye.

319 Shooting close-ups

Although many zoom lenses have a macro facility, they generally don't allow you to shoot true macro images, which have a reproduction ratio of lifesize or greater. To do that you'll need either a real macro lens or, alternatively, extension tubes or bellows.

320 Reversing rings

A cheap and easy way to shoot macro images is to use a reversing ring—this screws onto the front of your lens and allows you to mount it on the camera back to front so it focuses really close. Some functions such as autoexposure and autofocus will be lost.

321 Make the ordinary extraordinary

By going in really close you can turn everyday objects into fascinating images. Think of the patterns of veins and cells in a leaf or the tiny grains of pollen in a flower. Literally anything can be the source of a great photograph.

322 Patterns in nature

Mother Nature provides us with an endless range of subjects for close-up photography. Your own garden will be full of opportunities—from the detail in tree bark to lichens on rocks and stones, flowers, grasses, leaves, fungi, and much more.

323 Create your own subject

Why not try creating your own close-up still lifes? A great technique to try is placing things in a tray of water then letting it freeze—flowers, leaves, and berries are ideal.

324 As simple as that

Keep your close-up compositions simple. Concentrate on one key subject and make sure the background is uncluttered so it doesn't compete for attention—you can replace a natural background with a plain sheet of card if necessary.

325 Focus carefully

Critical focusing is essential when shooting close-ups because depth of field is minimal. The slightest change can throw your subject out of focus.

326 Maximize depth of field

To maximize depth of field, stop your lens down to its smallest aperture—usually f/22 or f/32 with macro lenses. Even then, the zone of sharp focus will be just a fraction of an inch if you're shooting at lifesize or greater.

327 Minimize depth of field

You can produce some great effects by shooting with your lens at its widest aperture—which minimizes depth of field—so only a very narrow zone of sharp focus is achieved while everything else is blurred beyond recognition.

328 Keep steady

It's much easier to achieve perfect focus if your camera is mounted on a tripod so that it doesn't move. Handholding is possible, but the slightest movement may throw your subject out of focus.

329 Put your subject in the shade

Harsh sunlight is generally unsuitable for close-ups. If you can't move your subject into the shade, create your own by holding a large sheet of card over it. White card doubles as a handy reflector.

330 Avoiding movement

Even the slightest movement can result in blurred or out of focus pictures when shooting close-ups. To avoid this, surround your subject with windbreaks—pieces of card are ideal for this.

331 Flash of inspiration

Using flash for close-ups solves numerous problems—the burst of light will freeze any movement, so you can work at smaller apertures to maximize what little depth of field there is, and the flash will provide even illumination in the shadiest spots.

332 Mirror lock

It's a good idea to use your camera's mirror lock when shooting close-ups so that vibrations are minimized when you trip the shutter—even the slightest vibration can reduce image sharpness.

333 Rainy day close-ups

One of the great things about close-up photography is you can practice it no matter what the weather's like. On rainy days you can either set up shots indoors using windowlight as illumination, or work outdoors under a large umbrella—as well as keeping the rain off it will also act as a diffuser and soften the light.

334 Flower power

Flowers are perfect subjects for close-up photography because they not only offer endless photographic options, from portraits to abstracts, but they are also available in a wide range of varieties and colors and can be photographed all year round, indoors and out.

335 The beauty of backlighting

Backlighting is a great way to reveal the colors and patterns in translucent subjects. Leaves are a common example, but spiders' webs, butterflies' wings, and many other natural subjects look their best when lit from behind.

336 Photographing texture

The world is full of fascinating textures—both natural and manmade—and the closer you look the more interesting they get. As well as obvious things such as tree bark, moss, and rocks, look at things like fish scales, blades of grass, sand, wood grain, skin, and fabrics.

337 What is it?

Why not photograph a selection of household objects close-up and see if your family can guess what they are? Kitchen implements, sponges, toothbrushes, and other everyday items can be used. You'll be surprised how different they look.

338 Just add water

Spraying flowers and plants with a mist of water will coat them in tiny droplets that sparkle in the light and add to the overall effect. Plant misters are ideal for this.

Nature and wildlife

From garden creatures to big game, the world is full of fascinating wildlife–and all of it makes for great photography.

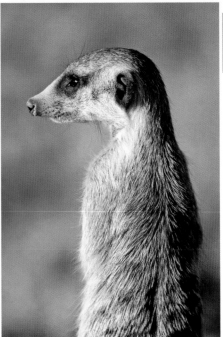

339 Using long lenses

Wild animals and birds are generally very cautious creatures, so to get frame-filling pictures you're going to need a long telephoto lens–300mm is about the minimum, but 400mm or even 600mm would be better.

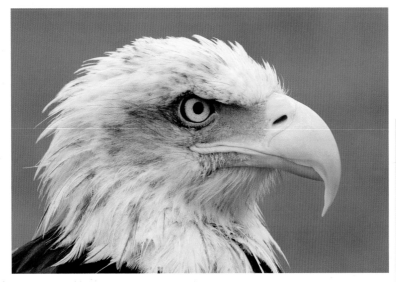

340 Blur the background

Use a wide lens aperture–possibly the widest your lens has–to minimize depth of field, so your subject is isolated from the background.

341 Fill the frame for impact

The most impressive wildlife pictures are those where the main subject fills the frame and makes the viewer feel that they're right there, up close and personal.

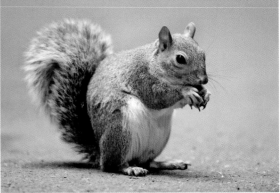

342 Shooting from a hide

A good way to get close to timid wildlife is to erect a hide in an area where animals or birds are frequent visitors. Don't expect instant success, though–it may take many visits before you get the right shots.

343 Knowing your subject

Successful wildlife photographers are also nature lovers who study their subjects, get to know the habits and habitats of their quarry, and are prepared to spend hour after hour just watching and waiting.

344 At the zoo

Zoos and wildlife parks offer a great introduction to nature photography because the animals and birds are captive, more used to humans, and you can usually get much closer to them than you can to their wild cousins.

345 Birds in flight

Capturing birds in flight is notoriously difficult, but modern autofocusing systems make the job much easier—use Predictive or Servo AF mode and practice at every opportunity to hone your skills.

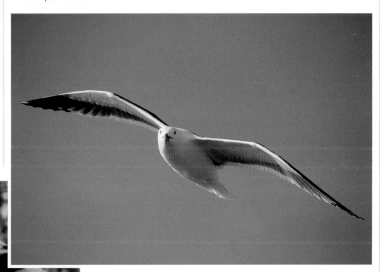

346 Animals in motion

Add impact to your pictures of moving animals and birds by using techniques such as panning to add motion—you can practice your skills by photographing a pet dog racing around.

347 Get down low

Wildlife shots always look more dramatic if you're shooting from your subject's eye level rather than above it. Better still, shoot from below their eye level to make them appear more menacing.

348 Use a teleconverter

If you can't afford a long telephoto lens, buy a 2x teleconverter to double the range of the lenses you already have—a modest 80-200mm zoom becomes a powerful 160-400mm.

349 Avoid flash

Avoid using flash for wildlife photography if you possibly can—not only is the light harsh and unflattering but it will frighten your subject, and after only one burst they will take flight.

350 Stalking your prey

If you want to achieve success when stalking wild animals, make sure you dress in drab or camouflage clothing, cover up any shiny or reflective surfaces on your camera and lenses, avoid wearing perfume, aftershave, or deodorants, and always stay downwind of your prey.

351 Shoot a sequence

If you keep your camera's motordrive set to Continuous mode you can shoot sequences of images—this is particularly effective if your subject is on the move.

352 Make the most of light

The quality of light can make or break a great wildlife picture. Fortunately, animals and birds tend to be most active at dawn and dusk when the quality of light is at its best.

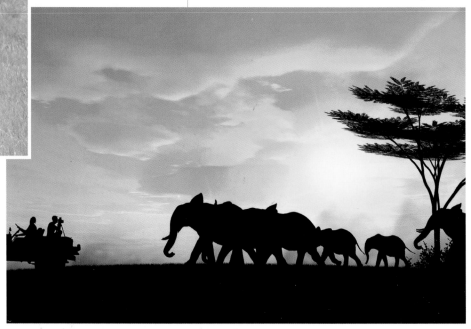

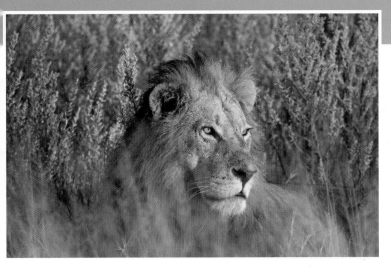

353 On safari

The ultimate in wildlife photography has to be shooting big game in exotic locations—so start saving! There are many specialist companies that organize guided photo safaris in Africa, Latin America, and India.

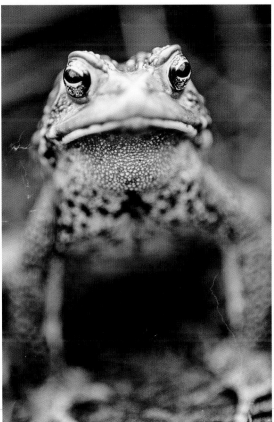

354 Your own backyard

Of course, you don't have to travel across the world to take great wildlife pictures—many species of animals and birds frequent gardens, parks, and even urban areas.

355 Keep the camera steady

Long lenses increase the risk of camera shake, so if you're using one, try to support it whenever possible. Walls, fallen trees, posts, and other natural supports are ideal, and a beanbag will provide a cushion to keep the lens steady.

Sport and action

Whether it's the Super Bowl or a game of soccer in your local park, the skills required to compose great action shots are the same.

356 Know the rules

The key to success in sports or action photography is to know your subject well enough to be able to predict what's likely to happen next and keep up with the action.

357 Everyday action

You don't need to visit major sporting venues to take great action shots. Everyday action–kids racing around on their bicycles or running along the beach, for example–can make great pictures.

358 Gaining access

To take great sports pictures you need to be as close to the action as possible. At major stadiums this is limited to professional photographers, but at local venues access will be less restricted, so they're well worth checking out.

359 Panning the action

Panning is one of the most effective ways of giving your action shots a sense of motion and drama. All you do is follow your subject with the camera by swinging from the hips and trip the shutter while moving so the background blurs but your subject stays relatively sharp. It's tricky to do well, but practice makes perfect.

360 Freezing movement

The single most important factor determining whether or not you freeze a moving subject is the shutter speed, and the one you need depends on how fast your subject is moving, how far away it is from the camera, and the direction it's moving in relation to the camera. Here's a list of suggested speeds for common subjects:

Subject	Across path Full frame	Across path Half frame	Head on
Jogger	1/250sec.	1/125sec.	1/60sec.
Sprinter	1/500sec.	1/250sec.	1/125sec.
Cyclist	1/500sec.	1/250sec.	1/125sec.
Trotting horse	1/250sec.	1/125sec.	1/60sec.
Galloping horse	1/1,000sec.	1/500sec.	1/250sec.
Tennis serve	1/1,000sec.	1/500sec.	1/250sec.
Car at 40mph (65kmph)	1/500sec.	1/250sec.	1/125sec.
Car at 70mph (110kmph)	1/1,000sec.	1/500sec.	1/250sec.
Train	1/2,000sec.	1/1,000sec.	1/500sec.

361 Tracking your subject

The only way to take successful action shots of moving subjects that don't follow a predictable path is by following them with the camera so you can shoot at the decisive moment. To keep your subject in sharp focus as you track it, set the autofocus to Predictive or Servo mode.

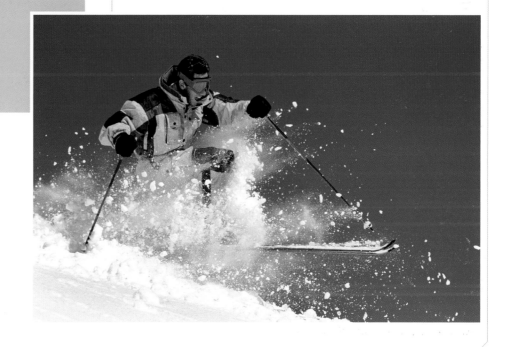

363 Timing is everything

Don't think that machine-gunning a subject with a fast motordrive guarantees you'll capture that decisive moment—it doesn't. Instead, you're better off shooting single frames so that you have to time each one to perfection.

364 Account for shutter lag

When you trip the camera's shutter to take a picture there's a fractional delay before the shutter opens. With fast-moving subjects this delay can make or break a great shot, so remember to fire just before the crucial moment.

362 Slow-sync flash

A great technique to use when you want to emphasize motion is slow-sync flash. This involves shooting with your camera on a slow shutter speed so the subject blurs while also firing a burst of flash that freezes the subject. Try it at the carnival or when shooting sport at close range, and set your camera or flash to rear-curtain sync.

365 Shoot a sequence

Sequences of action pictures can often be more telling and dramatic than single frames, so don't be afraid to set your camera's motordrive to Continuous and keep your finger on the shutter to expose several frames in quick succession.

366 Practice makes perfect

Photographing sport and action is perhaps the hardest photographic job you'll encounter because you need fast reflexes and perfect timing. Initially your hit rate will probably be low, but the more you practice the better you'll become.

367 Go wide

Although telephoto lenses are the mainstay of sport and action photographers, you can get stunning pictures by moving in really close with a wide-angle lens. Events such as marathons, fun runs, and city center cycling are ideal for this technique because you can get close to your subject. BMX stunt biking and skateboarding are other subjects worth shooting with wide lenses.

368 Isolate your subject

For most sport and action subjects you'll need a telephoto or telezoom lens so you can isolate your main subject from a distance and fill the frame for maximum impact. A basic 80-200mm zoom will be fine for close-range action, but serious sports photographers often work with lenses ranging from 400 to 600mm.

369 Use blur creatively

Action pictures don't have to be sharp. In fact, in many cases some creative blur will actually produce a more effective image, so experiment with slow shutter speeds when photographing everyday moving subjects and see what happens.

370 Watch the background

Sporting venues are often littered with advertising hoardings that can make the background very distracting. The same applies if you're shooting toward crowds of spectators. To avoid problems, find a vantage point where the background is less cluttered. Failing that, shoot with your lens at its widest aperture to minimize depth of field, or pan the camera so the background blurs.

371 Unusual angles

Try shooting popular sports from unusual angles. Place your camera on the ground so it's pointing up, for example, or find a high viewpoint so you're looking down. You could also set shots up—maybe laying on the ground and asking your subject to jump over you so you can capture them with a wide-angle lens against the sky.

372 Digital action

One of the great things about digital photography is that you can instantly assess whether you got the shot, and with no film and processing costs to consider you can shoot as many frames as it takes to get that picture. The rejects can be deleted later.

373 Capturing crowds

Rush hour in big cities is a fascinating sight, with thousands of commuters rushing along station platforms and busy streets. To capture the drama of this, use a shutter speed of a second or two to blur the bustling bodies. The same technique works well in busy markets and squares.

374 Firework Fun

Aerial firework displays make stunning abstract photographs. All you need to do is mount your camera on a tripod and lock the shutter open on bulb as the fireworks are launched. Keep it open for half a minute or more to capture several bursts on one frame, or combine several frames digitally.

375 Traffic trails

To record the lights of moving traffic as colorful streaks, find a view over a busy road and, with your camera on a tripod, take a picture with a bulb exposure of between 20 and 30 seconds.

Vacations and travel

From family vacations to global adventures, our travels expose us to a myriad of fascinating and often exotic subjects. Here's how to do them justice.

376 Do your homework

It's worth researching your holiday destination to assess its photographic potential. Just do an internet search on the place and see what comes up, or enter the destination into the search engine of a picture library's website and check out the images that come up. The more you know about a place before you get there, the less time you'll waste when you arrive.

377 Check out the postcards

Postcards are always a good indication of the most popular subjects and scenes in a location, so check them out as soon as you can and buy a selection to use as visual reminders.

378 Make the most of light

Early morning and evening are the best times of day for travel photography—not only because the light quality is high but also because there are fewer tourists around to spoil the view.

379 Less is more

When you're traveling, everything seems new, different, and exciting, and it's tempting to use your camera like a gun, blitzing everything in site. However, if you do that you'll be disappointed with most of the pictures, so try to resist and think carefully about each shot you take.

380 Shooting famous monuments

Famous monuments—the Empire State Building or the Eiffel Tower, for instance—have been photographed millions of times, so if you are going to shoot these, try to come up with something original. Visit early or late in the day when there a fewer people around, experiment with unusual camera angles, use extra-long or extra-wide lenses, shoot panoramas...

381 Off the beaten track

Don't just photograph the obvious subjects and scenes—get off the well-worn tourist trail and look for something new.

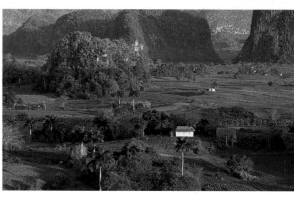

382 Avoiding the clichés

It's hard to avoid shooting clichés when traveling because they present themselves at every turn. However, if you get them out of the way as soon as you arrive you can then concentrate on producing original work.

383 Life's a beach

Tropical beach scenes are irresistible to photographers because they're symbolic of so many things—tranquillity, paradise, escape, etc. Shoot them in the middle of the day—a time when many tourists will have retreated to the shade to escape the heat, so leaving the scene clearer for you. The overhead sun will make the sand shimmer, and the sea will reflect the blue sky and look amazing.

384 Capture symbolic details

Small details can say as much about the character of a place as grand views or famous monuments. They're also often far more interesting photographically because they're less corny.

385 Put people in the picture

Local people give a place its character as much as the buildings and landscape, so don't be afraid to shoot a few portraits during your travels. If you ask permission rather than trying to grab shots, you'll be surprised just how responsive people are to being photographed.

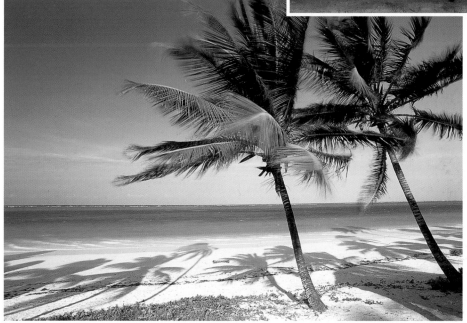

Pictures For Profit

Shooting For stock
In this digital age, the stock photography industry is booming, and, more than ever before, amateur photographers with an eye for a picture can grab a piece of the action.

386 What is stock photography?

Stock photographs are those held by picture libraries, which license images for use in advertising, publishing, and other media. In return for marketing your work the library takes a commission from each sale–usually 50 percent–although there's nothing to stop you setting up on your own and marketing direct. Shoot the right images and it can be a lucrative business; shoot the wrong ones and sales will fail to materialize.

387 Quality counts

Image quality is paramount if you want your images to be accepted by libraries. They must be sharp, well exposed, well composed, and commercial. If you shoot digitally, your camera must also have a minimum resolution of 10 megapixels, otherwise file sizes will be too small, and the images will be rejected.

388 Different angles

Stock photographers tend to work a subject or scene until they can't think of any other angles to capture it from. This is a good way to work, because even small variations in a composition can increase the commercial appeal of a picture.

389 Different formats

Try supplying the same image in different formats. For example, make several copies of one shot then crop one to a panoramic, one to a square format, one to an upright, and so on. Although it's the same shot, by presenting it in a number of different ways it will appeal to a wider range of markets.

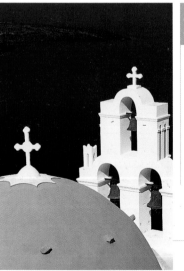

390 It's a numbers game

Stock photography is ultimately a numbers game–the more pictures you have with a library the more sales you're likely to make. However, at the same time, a small selection of top-quality pictures will sell better than a large collection of mediocre ones.

391 Compose to crop

Although tight, careful composition should be your goal, with stock photography it sometimes pays to leave a little more space around your subject than you would normally so that the image can be cropped to different shapes and formats without the meaning of the picture being lost.

392 Imagine how the picture might be used

When you're composing a photograph for sale, try to visualize how it could be used. Would there be space for text or maybe a magazine cover logo at the top? If it was used across a double-page spread, would important subject matter get lost where the pages join? Sometimes it will be necessary to shoot the same scene or subject in a variety of different ways to cover all the bases.

393 Make it suitable for different markets

The best-selling stock images are those that appeal to many different markets, so shoot accordingly. Ask yourself who might buy that picture before you take it, and if you don't know the answer, think again.

394 Avoid people

Copyright and privacy laws are becoming stricter all the time, so many of the bigger global photo libraries will now reject any images that include people unless a signed model-release form is supplied. This includes travel portraits, crowd scenes, and even shots where the person or persons included aren't identifiable.

395 Don't take pictures that date

Anything that could date a stock image will, at best, reduce its shelf life and, at worst, mean that it's rejected out of hand. So avoid traffic because license plates are date sensitive and people because fashions change.

396 Exclude names and brands

Brand names are covered by copyright and therefore cannot be featured in stock images as use of those images would be limited.

397 Be creative with composition

Stock photography used to be very traditional and quite dull, but today it's different. Buyers of stock images expect original, exciting, innovative work–as creative as if they had commissioned it themselves.

398 Try something different

Don't be afraid to experiment when shooting stock images. By all means take the obvious pictures first, but then try something different–the worst that can happen is that they're rejected, but you could be pleasantly surprised.

399 Mood sells

The most successful stock landscape images have mood and atmosphere. Lake scenes photographed at sunrise or sunset are classic–especially if they have soft, warm colors, calm water, reflections, and maybe a jetty and boat thrown in for good measure!

Products for sale

Whether it's for auction sites or small adverts in a local paper, taking good pictures of things you want to sell will increase their sales potential tenfold.

 ### 400 Make sure they're clean

Why would anyone want to buy something that looks dirty and unloved? Exactly—so make sure everything you want to shoot is clean and tidy before reaching for a camera. It's amazing what a damp cloth and duster can achieve!

 ### 401 Choose a simple background

Potential buyers want to see the item for sale not the pattern on your dining-room wallpaper or the creases in your quilt, so always use a plain, simple background. White card is ideal for smaller objects, while a neutral-colored wall will suit bigger items.

 ### 402 Shooting in windowlight

Direct, on-camera flash is highly unflattering, so avoid it at all costs and instead use windowlight—it's much softer and easier to control. For small items place your white-card background next to a window, and you'll get far better results.

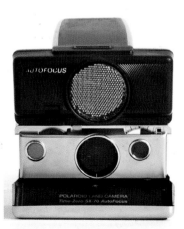

 ### 403 Use a reflector

If necessary, you can bounce light into the shadows using a reflector—another sheet of white card will do. Place it opposite the window for a nice, even effect.

 ### 404 Shoot different angles

Depending on what it is you're selling, it's worth shooting it from a variety of different angles so potential buyers can get the best possible idea of what they're considering spending their money on.

 ### 405 Head on

Start with a simple head-on shot with the object pointing toward the camera.

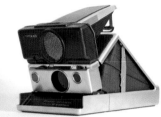

 ### 406 Three-quarter

Next, turn it 45 degrees to the left and take a shot, then 45 degrees to the right and take a third shot. This angle tends to be the most effective.

 ### 407 Side view

For a full profile, turn the item 90 degrees. Repeat for both sides.

408 Top view

Now stand over the item and take a view looking straight down on it. Use a stepladder for bigger items.

409 Base view

If it's necessary, turn the item over and show its underside—for example, anyone thinking of buying a canoe would want to know what state it was in underneath.

410 Back view

Again, if it's possible or relevant, take a shot showing the rear of your item.

411 Show scale

With smaller items such as jewelry or anything else where size is relevant, it's worth taking a picture with a ruler or some other method of comparison in the composition to show the size or scale of the item.

412 Reveal imperfections

Rather than hide imperfections, you need to show them so the eventual buyer is fully aware of the condition of the item. These imperfections should be listed in the description but also photographed in close-up.

413 Adjust levels and curves

Once you've taken the shots, some quick postproduction tweaks may be necessary to get them looking perfect. With white backgrounds, for example, go into Photoshop and use Image>Adjustments>Levels and pull the Highlight slider to the left until the background is pure white.

After The Shot

Composing in-computer
Although it's always better to compose a picture as you want it at the time it's taken, sometimes a composition can be improved postproduction when you have more time to think about it.

The tips in this section reveal what can be achieved using Photoshop.

414 Crop during scanning

If you're scanning a slide, negative, or print, the image can be cropped using controls in the scanner software, although it's better to scan full frame as you may change your mind later.

416 Use the Crop tool

The easiest way to crop an image is by using the Crop tool in your editing software—drag the tool across the image to highlight the whole image area then adjust the crop lines on each edge until you're happy with the new crop.

415 Opening the image

Once the image has been scanned or imported to your computer from a memory card or direct from the camera, open it in Photoshop—or whichever editing software you use—so work can begin.

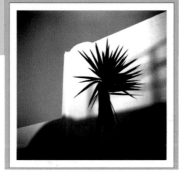

417 Increase the canvas size

Placing a neat white or black border around a picture can help to make the image stand out. Do this using Image>Canvas Size. In the dialog box choose the Canvas extension color you want for the border then increase the canvas dimensions a little and click OK.

418 Flipping an image

Sometimes you may find that a composition works better if the image is flipped horizontally. Do this using Image>Rotate Canvas>Flip Canvas Horizontal–remembering, of course, that any words or numbers in the picture will be reversed.

419 Straighten lopsided horizons

One of the most common compositional mistakes is not getting the horizon straight. Fortunately, this is easily remedied by selecting Image>Rotate Canvas>Arbitrary and rotating the image clockwise or counterclockwise until the horizon is straight. The image will then need to be cropped, as in tip 416, to tidy it up.

422 Pictures within a picture

If you take a close look at one of your favorite photographs, chances are you'll find a number of other more selective compositions within the overall scene. These can be isolated by cropping and copying to create scenes within a scene.

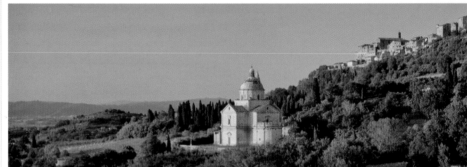

420 Rotating the image

You can use Image>Rotate Canvas>Arbitrary in a more extreme way by intentionally tilting an image to one side or the other. If necessary you can then recrop it, although this isn't essential.

421 Always make a copy

Always make a copy of the master file before you start experimenting with an image. That way, if you take things too far and spoil it, you still have the original. Alternatively, go through the History palette and delete any changes you're unhappy with.

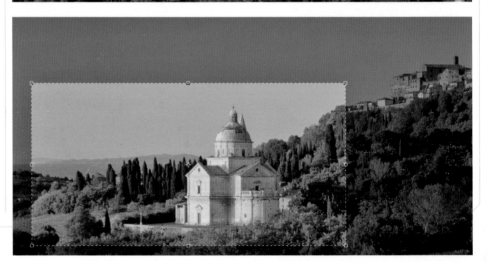

423 Radical crops

Although you will normally make small and subtle adjustments to a composition by cropping in-computer, there's nothing to stop you being more bold—so experiment and see what happens. Throw caution to the wind and break some rules!

424 Creating panoramas

The most effective way to create digital panoramas is by shooting a sequence of images and stitching them together, but cropping a single frame to a panorama is also an option. Both horizontal and upright panoramas can be created this way—the only downside being that the maximum output size of the image will be reduced.

425 Changing format

Think a composition would work better if you change from landscape to portrait, or rectangle to square, or vice versa? Then do it. The Crop tool in Photoshop is a wonderful thing when used carefully and creatively.

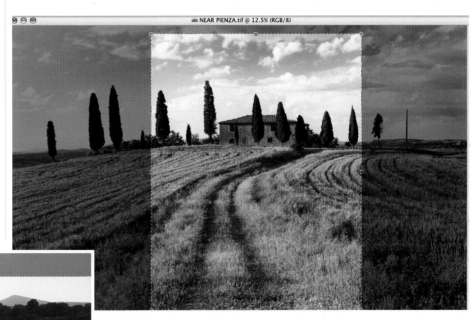

426 Rescue bad shots

Although you should never rely on it or use it as an excuse for sloppy workmanship, digital technology does now make it possible to rescue the most badly composed photograph and make something interesting from it.

Cropping slides and prints

If you're a traditionalist and prefer to use film rather than shooting digitally, it's still possible to alter the composition of your pictures long after they are taken.

427 In-camera slide duplicates

Slide duplicates are costly and never as good as the original, so it's much better—and cheaper—to take three or four identical shots of the same scene. That way you'll have several original copies that you can play around with.

428 Using a lightbox

The quickest and easiest way to assess color slides—and, to a lesser extent, negatives—is by placing them on a lightbox and scrutinizing them in detail with a magnifying lupe.

429 Think before you crop

If you're not happy with the composition of a slide or print, think carefully before making changes—live with the image for a while and keep going back to it until you're sure you know how you want to change it.

430 Slide mounts and masks

Ideally, color slides should be mounted in card or plastic mounts or, better still, black-card masks. Not only does this protect the delicate film and make handling easier, but it also shows off the image more effectively by framing it.

431 Masking off areas

You can alter the composition of slides by placing small pieces of silver foil in the mount to mask off the areas you want to hide.

432 Flipping a slide

If you think that an image looks better when viewed the wrong way round, you can always flip it in the mount. This won't make any difference to how it appears when projected or viewed on a lightbox—although numbers and words will be reversed.

433 Preshaped masks and frames

Slide-mount manufacturers—Gepe, for example—make special preshaped masks that slip into the slide mount so you can change the format. As well as different rectangles and squares, ovals and circles are available too for something different.

434 Change the format

Slide masks come in all the different standard medium formats—2¼ x 1¾in, 2¼ x 2¼in, 2¼ x 2¾in (6 x 4.5cm, 6 x 6cm, 6 x 7cm), and so on. If you shoot one of the bigger formats, you can place the slides in 2¼ x 2¼in or 2¼ x 1¾in (6 x 4.5cm, 6 x 6cm) masks to change the format and composition if you're not happy with the full-frame image or feel that the same shot would benefit from being composed in different ways.

435 Printing panoramas

The most effective way to print panoramas is by using paper rolls instead of sheets, so you can create big prints that really show off the quality of the images. A modestly priced super-B (A3) printer will accept 13in (33cm) paper rolls, so for images with a 3:1 format you could produce 13 x 39in (33 x 99cm) prints.

436 Make proof prints first

Before committing to a full-sized print, which will be costly in terms of paper and ink, make a smaller proof print first that you can assess. If you then decide to make any changes, the wastage won't be excessive.

437 On its head

It's said that if you look at a photograph upside down—the photograph, not you!—you can assess the composition more objectively, and if the composition works when it's upside down it's bound to work the right way up. Try it!

438 Print the wrong way round

In the same way that a slide can be flipped and mounted back to front, negatives can also be printed the wrong way round, so the image is reversed.

439 Creative darkroom cropping

If you still make traditional prints in a darkroom there's no end to the cropping options you have by simply adjusting the masking blades in the enlarger's negative carrier or the blades in the masking frame that holds the printing paper. Rectangle, square, panorama—the choice is yours.

440 Printing full frame

Alternatively, you could print full frame and include the edges of the film rebate as a black border—proof that if you get the composition right in-camera, you don't need to change it later.

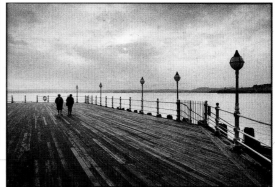

Image Improvement

Enhancement and presentation
Photography doesn't stop when you trip the camera's shutter–often that's just the beginning of a fascinating creative process. Photoshop offers a variety of options for improving and altering images, while both traditional and contemporary methods of printing and framing photographs can add a whole new dimension to your work.

Assessing your images

If you want to learn from your mistakes and become a better photographer you need to analyze your work and assess why an image works–or if it doesn't, why doesn't it, and how could it be better?

Making contact sheets

Producing contact sheets of your digital images makes it easier and quicker to assess them. You can also scribble notes on the sheets and put cropping lines on for future reference. The Contact Sheet function in Photoshop–File>Automate>Contact Sheet–makes light work of this.

443 Removing unwanted elements

Some photographers regard it as cheating, but removing unwanted details from an image is a great way to tidy up and simplify a composition. Use the Clone Stamp and Healing Brush tools in Photoshop to zap small details.

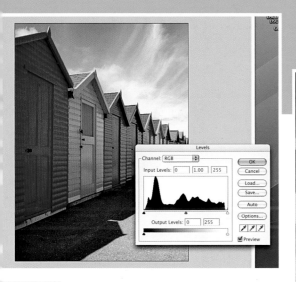

447 Increase the canvas size

It's easier to assess an image on a monitor screen if it's set against a plain background. Create one simply by increasing the canvas size of the image and using either white or black as the canvas color–Image>Canvas Size.

444 Adjust Levels and Curves

The two most useful controls you will turn to for pretty much every image you work on digitally are Image>Adjustments>Levels and Image>Adjustments>Curves, as they allow you to fine-tune contrast and tonality to get the feel of the image just right.

445 Balance the colors

Image>Adjustments>Color Balance is a handy function to use if an image exhibits an unwanted color cast, because you can adjust the sliders in the dialog box to get rid of it–or, equally, you can add a cast if you want one.

446 Image sharpening

Digital images–either from digital cameras or scans–often need to be sharpened to bring out all the detail they have resolved. The Unsharp Mask tool is designed to help you do this–but use it carefully and avoid the temptation to overdo it.

448 Adding a keyline

A narrow black line around the edge of an image can also look highly effective. To create one, open the image then go to Select>All then Edit>Stroke, enter a small value such as 3 or 5 in the Width window, click OK, and a fine black keyline will be created. Next, increase the canvas size a little to show the keyline off.

449 Creative borders

Instead of a keyline, try experimenting with bolder borders. To create the basic border, increase the canvas size by 10 or 15 percent and use black as the extension color. All you do then is paint away the outer edges of the border using the Eraser tool and the Pastel Medium Tip brush found in the Dry Media Brushes palette.

450 Printing your pictures

The best way to view any photograph—whether it started life as a slide, negative, or digital file—is in print form, so don't let your favorite pictures languish in drawers or on computer hard drives. Modern ink-jet printers are capable of amazing results and are easily affordable.

451 Window mounting

Prints always look more effective when they're window mounted. Any picture framer will make custom mounts for you, although good quality mount cutters aren't expensive and allow you to make your own. .

452 Use protective sleeves

If you don't want to frame your mounted prints, place them in clear polyester sleeves—not only will they look great but the delicate print surface will also be protected.

453 Put together a portfolio

In fact, if you're going to sleeve your mounted prints, you might as well go the whole hog and buy a good quality portfolio box or case to store them in as a collection. A wide range are available from darkroom suppliers.

454 Framing prints

The only downside with hiding prints away in boxes is that few people will ever get the chance to appreciate them, so why not frame a selection of your favorites and display them in your home? Better still, why not put on a small exhibition so your work can be enjoyed by a wider audience—you may even sell a few!

455 Canvas prints

Many ink-jet printers can now handle canvas sheets and rolls, so it's possible to make your own canvas prints then attach them to wooden frames to create professional-standard results for a fraction of the price.

456 Creative presentation

As well as traditional framing and canvas printing, there are numerous more contemporary ways of presenting your images that are worth considering—try laminating prints between acrylic sheets or bonding the print to aluminum panels.

The magic of monochrome

Black and white may be perceived as old fashioned, but to creative photographers it's the most expressive medium available.

457 Converting to black and white

Just because you take a photograph in color, it doesn't have to stay that way—converting it to mono can give it a whole new lease of life.

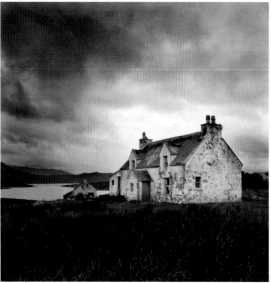

459 Using Channel Mixer

A more effective method of converting color to mono is using Image >Adjustments>Channel Mixer, checking the Monochrome window in the dialog box, then adjusting the sliders for the red, green, and blue channels to alter the tonal balance and contrast of the image.

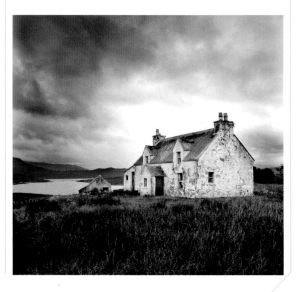

458 Simple desaturation

The easiest way to convert a color image to black and white is by using Image>Adjustments> Desaturation, although serious mono workers consider this to be the least effective method, as the resulting image is often quite flat.

462 Dodging and burning-in

You can dodge (lighten) and burn (darken) areas of an image digitally in the same way as you can in the traditional darkroom. For large areas, make selections with the Lasso tool and lighten or darken them. For smaller areas use the Dodge tool and a soft-edged brush.

460 Creating high contrast

In the traditional darkroom, high-contrast images were created using hard-contrast grades such as IV or V or, in extreme cases, lith film, which produced pure black-and-white images with no midtones. In the digital darkroom (lightroom) you can use Image>Adjustments>Brightness/ Contrast or Image>Adjustments>Levels and Image>Adjustments>Curves to do the same job.

463 Quick and easy grain

There are various ways to mimic the effects of fast, grainy film in Photoshop. Adding Noise is the easiest (Filter>Noise>Add Noise) followed by the Grain filter (Filter>Texture>Grain).

461 Filter effects

Red, orange, yellow, and green filters are used to change contrast and tonality when shooting black-and-white film. To mimic the effects of these filters digitally, use Channel Mixer. For example, if you set the red channel to 100 percent and both blue and green to 0 percent, the image will look as though it was shot through a red filter.

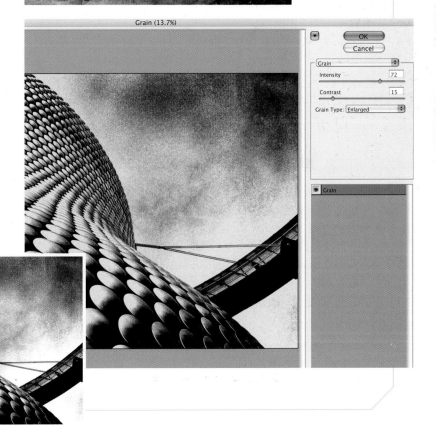

464 Toning with Hue/ Saturation

A quick and easy way to tone a black-and-white image is by using Image>Adjustments>Hue/Saturation, then clicking on the Colorize box and adjusting the Hue and Saturation sliders until you're happy with the effect.

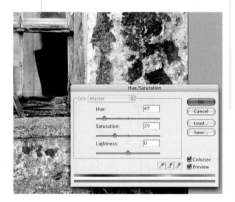

465 Sepia toning with Curves

Open your image and go to Layer>New Adjustment Layer>Curves. In the Curves dialog box select the blue curve, and from the center drag it down and to the right a little; then select the green curve, and from the center drag it to the right a little. Finally, select the red curve, and from the center drag it a little to the left.

466 Blue toning with Curves

Follow the same steps as tip 465, but drag the blue curve to the left. The more you drag it, the bluer the tone. You can also adjust the tone using Hue/Saturation and tweaking the saturation slider.

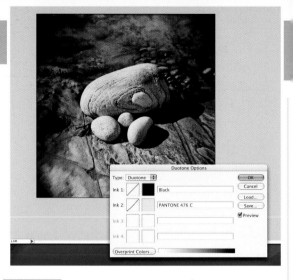

467 Duotone effects

Images printed in duotone have a wonderful warmth and depth to their tonality. To create this effect in Photoshop, convert the image to grayscale (Image>Mode>Grayscale) then use Image>Mode>Duotone and choose your second ink color from the Pantone list available.

468 Tritones and quadtones

Once you've mastered duotone, try tritone (two colors plus black) and quadtone (three colors plus black). By carefully adjusting the curve for each color you can achieve beautiful split-toned effects and put different colors in different parts of the tonal range.

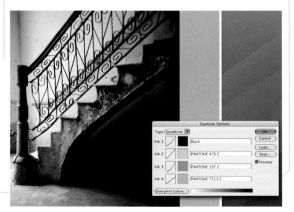

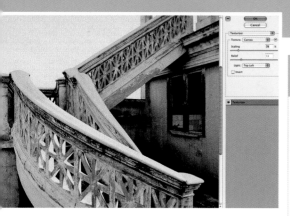

471 Make them look old

Try mimicking the effects of old photographic processes such as gum printing and cyanotype. For gum prints, add a sepia tone (see tip 465), then texture (see tip 468) before adjusting Image>Adjustments>Levels and Image>Adjustments>Curves to flatten the image. Cyanotypes have a ragged border and a strong blue tone.

469 Canvas prints

To add texture to your images use Filter>Texture>Texturizer, select one of the options in the Texture window—such as sandstone or canvas—then adjust Scaling and Relief until you're happy with the effect.

470 Solarization

Mimic the effects of print solarization using Filter>Stylize>Solarize and adjust Levels and Channel Mixer to get the effect you want.

472 Liquid emulsion

Coating handmade paper with liquid emulsion produces images with a wonderful texture and stylish brush-stroke border. To mimic the effect digitally, paint black acrylic paint onto a sheet of white art paper, scan it to create a template, then combine it with black-and-white images and use Layer>Layer Style>Blending Options>Lighten so the image shows through the mask.

Creative ideas

One of the most satisfying aspects of photography is creating unique and imaginative images. Here are some ideas to keep your inspiration high.

Stitching images together

Creating stunning panoramas has never been easier thanks to the availability of many different software packages that allow you to digitally "stitch" together a series of individual frames. This gives you the flexibility to cover up to 360 degrees, and the seamless results can look amazing.

474 Create a joiner

The artist David Hockney invented this unusual technique in the 1980s, by taking dozens, sometimes hundreds, of pictures of the different elements in a scene then putting them together to create amazing montages. You can re-create the effect digitally by selecting small areas of a photograph, copying them, then pasting them onto a new canvas.

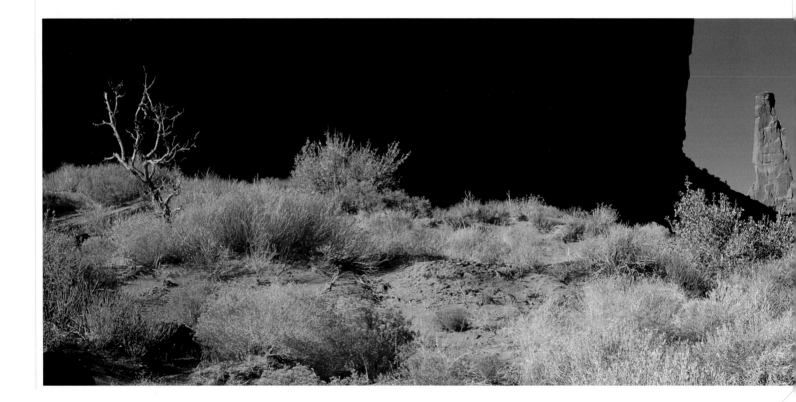

475 Photoshop Filters

Although some of the effects can look rather gimmicky, it's well worth experimenting with some of the Photoshop filters—the Blur, Grain, and Distort tools are particularly effective.

476 Design a diptych

Take one of your favorite photographs, cut it in half, and copy and paste each half onto a new canvas with a space between the two to create an eye-catching diptych. Better still, print the two halves separately, put them in a pair of matching frames and mount them on the wall side by side—or one above the other if the original shot was an upright.

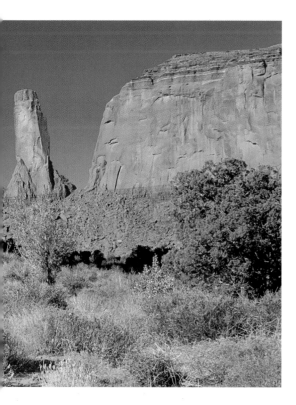

477 Changing the sky

If you have a photograph that is perfect apart from a boring sky, why not find another shot with a more interesting sky then copy and paste it over the original? You'll need to choose the donor sky carefully so it looks natural on the new photograph, but get it right and no one will have a clue what you've done.

478 Mirror images

Take a photograph of a bold subject such as a building or bridge, copy one half, flip the copy using Image>Rotate Canvas, then, on a new canvas, paste the copied half and move the original half. Merge them together, and you'll have a fascinating mirror image. This technique also works well on portraits, creating some very weird results.

479 Add soft-focus effects

Soft focus, or diffusion, filters have always been popular among photographers for everything from landscapes and portraits to still lifes and close-ups. However, in this digital age you can re-create the effect very quickly and easily using Photoshop filters such as Gaussian Blur—and you can control the level of diffusion to suit each image.

480 Merging images

Photoshop and other imaging-software packages give you endless control in combining or merging images, and the effects can either be totally realistic or out of this world. To make the joins seamless, it's easier to work with images that were all shot against the same white or black background.

481 Working in layers

It's always a good idea to use adjustment layers when combining images or adding effects to an image because you can work back through the layers and delete those effects or images that you no longer want.

482 Selective coloring

Hand-coloring black-and-white prints is a technique that requires time, patience, and lots of skill. Luckily, you can achieve perfect results in Photoshop quickly, easily, and with great accuracy. All you do is select areas of the original color image using the Lasso tool and covert them to black and white, or convert the whole image to black and white using Image>Desaturate, then select areas and paint color back into them using the Paint tool.

483 Multiple exposures

Using Layers you can combine as many images as you like to create unusual multiple exposures. Try taking several pictures of the same person, each slightly different, then lay them one on top of the other, using Blending Modes and the Opacity slider to control how the final image appears.

484 Try something different

The photographs you produce are limited only by your own imagination, so experiment, take creative risks, and see what happens—you could be pleasantly surprised.

485 Create a triptych

If you tried out tip 476 and liked the results, try taking things a step further and create a triptych—instead of dividing an image into two, divide it into three. Alternatively, take three shots of the same subject, moving the camera to the right after each one so there's only a slight overlap between them. Still-life shots can also be set up specifically to create a triptych.

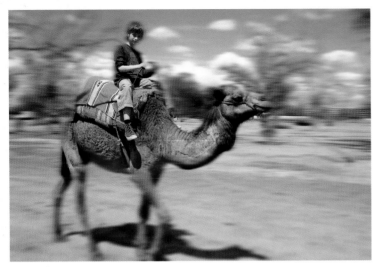

488 Building a picture

If you don't like the composition of a picture, try copying key components from it then resizing and rearranging them. Doing this allows you to control perspective and scale, fill empty space, and create imaginative images from nothing.

489 Adding texture

You can add texture to images by creating your own texture screens then combining them in Layers with the main image. Try scanning a piece of greaseproof paper or sandpaper then experimenting with different blending modes and opacity to combine the layers until you're happy with the end result.

486 Creating movement

It's easy to take a picture of a static subject then apply Photoshop effects to add the impression of motion. The Motion and Radial Blur filters are the most effective, and you can apply them to the whole image or selectively to specific areas.

487 Zooming effects

Ever tried zooming your lens during exposure so your main subject records as colorful streaks exploding from the center of the frame? If the answer is "No," you must give it a try–the results can look amazing. If you're feeling lazy, the Radial Blur filter produces very similar results.

490 Blur the background

Distracting backgrounds can ruin a picture. Shooting at a wide aperture to reduce depth of field can make a messy background less obtrusive, but, if that doesn't work, use the Lens Blur filter to throw it completely out of focus.

491 Removing unwanted elements

One of the great things about digital imaging is that if you don't want something to appear in a picture you can just get rid of it using the Clone Stamp or Healing Brush tools. Things like telegraph wires and poles, discarded litter, or anything else that spoils a shot can be removed with just a few clicks of a mouse.

492 Imitate a Holga

"Toy" cameras such as the Holga are popular, and you can easily mimic the effects they create using Photoshop—simply crop your chosen image to a square, add a black border, then blur and vignette the outer edges of the image by making selections with the Marquee tool, applying Gaussian Blur, and adjusting Levels.

493 Make the most of actions

Many Photoshop techniques are complicated and require many steps to complete. Save time by downloading actions and plug-ins that contain these steps. All you need to do is select your image, hit the return key, then sit back and let the computer do its job.

494 Take a chance

"Nothing ventured, nothing gained" is a philosophy well worth adopting when it comes to photography—especially when experimenting with new ideas. Unless you try something, you'll never know how well it works.

495 Restore old photographs

Photoshop is ideal for restoring old photographs—tears, scratches, holes, and creases can all be retouched to bring your ancestors back in all their former glory.

496 Look for inspiration

If you reach a creative dead end, a great way to find inspiration is by looking at the work of other photographers in magazines, books, exhibitions, and on websites. One image can spark an idea in your own mind, and before you know it your creative juices will be flowing again.

497 Distorting shapes

Go to Filter>Distort and you'll find various tools that allow you to distort images in different ways. Pinch, Shear, Spherize, Twirl, and Liquify create some weird and wonderful effects that are well worth experimenting with.

498 Cross-processing effects

Cross-processing color film in the wrong chemistry is a fiddly and unpredictable process, but, fortunately, you can achieve very similar results digitally by playing with the RGB curves of an image plus Levels and Hue/Saturation.

499 Experiment with hue and saturation

Although the Saturation slider in Photoshop should generally be used with caution, there's nothing to stop you really going to town on the right image. Close-ups of flowers and abstract shots of architectural details can benefit from extreme saturation increase, while playing around with the Hue slider can produce surprising results as well.

500 Adding text to images

Turn your favorite photographs into professional-looking posters or cards by adding text. Simply increase the canvas size to create space for the text, then add it using the Text tool.

Glossary

Ambient light
Available light, such as daylight, tungsten room lighting, or windowlight.

Aperture
The hole in the lens through which light passes en route to the film. Each aperture is given an f/number to denote its size. Large apertures have a small f/number, such as f/2.8; small apertures have a large f/number—f/16, for example.

Backlighting
The term used to describe shooting toward a light source, so your subject is lit from behind.

B setting
A shutter setting that allows you to hold your camera's shutter open while the shutter release is depressed. Useful for night photography when the exposure time required runs outside the shutter-speed range on your camera.

Burning-in
A darkroom and digital technique where more exposure is given to certain areas of the print or image, such as the sky, to darken them down or reveal detail.

Catch light
The reflections created by highlights or bright objects that appear in your subject's eyes and make them look more lively.

Color contrast
Using colors together that clash when in close proximity to one another—red and blue, for example.

Color harmony
Using colors together that harmonize and produce a soothing result—green and blue, for example.

Color sensitivity
How well film responds to light of different wavelengths—some films are more sensitive to certain wavelengths, particularly red and blue.

Color temperature
The scale used to quantify the color of light, measured in Kelvin (K).

Contrast
The difference in brightness between the highlights and shadows in a scene. When that difference is great, contrast is high; when it's small contrast is low.

Contre-jour
A French term that means shooting into the light—literally, "against the day."

Converging verticals
A problem common in architectural photography that makes buildings appear to be toppling over. It's caused when the camera back is tilted to include the top of a structure.

Depth of field
The area extending in front of and behind the point you focus on that also comes out acceptably sharp.

Depth of field preview
A device that stops the lens down to the taking aperture so you can judge depth of field.

Exposure latitude
The amount of overexposure and underexposure a film can receive and still yield acceptable results. Color-print film has a latitude of up to three stops over and under.

Fast lenses
Lenses with a wide maximum aperture, such as a 300mm f/2.8 or a 50mm f/1.4.

Flare
Nonimage-forming light that reduces image quality by lowering contrast and washing out colors.

Flash-sync speed
The fastest shutter speed you can use with electronic flash to ensure an evenly lit picture. It varies depending upon camera type—and can be anything from 1/30 second to 1/250 second with most SLRs.

Focal length
The distance between the near nodal point of the lens and the film plane when the lens is focused on infinity. Also used to express a lens' optical power.

Focal point
The point where light rays meet after passing through the lens to give a sharp image. Also used to describe the most important element in a picture.

Highlights
The brightest part of a subject or scene.

Hyperfocal distance
The point of focus at which you can obtain optimum depth of field for the aperture set on your lens.

ISO
The acronym for International Standards Organization, the internationally recognized system for measuring film speed.

Lens hood
An accessory used to shade the front element of your lenses from stray light, so reducing the risk of flare.

Lifesize
A term used in close-up photography when the subject is the same size on film as it is in reality.

Low key
A picture that has mostly dark tones, so giving it a dramatic, moody feel.

Magnification ratio
Also known as reproduction ratio, this refers to the size of a subject on a frame of film compared with its actual size.

Medium-format
A type of camera using 120-roll film. Image sizes available are: $2^{1}/_{4}$ x $1^{3}/_{4}$in, $2^{1}/_{4}$ x $2^{1}/_{4}$in, $2^{1}/_{4}$ x $2^{3}/_{4}$in, $2^{1}/_{4}$ x $3^{1}/_{8}$in, $2^{1}/_{4}$ x $3^{1}/_{2}$in (6cm x 4.5cm, 6cm x 6cm, 6cm x 7cm, 6cm x 8cm, 6cm x 9cm).

Mirror lock
A device found in some cameras that allows you to lock up the reflex mirror prior to taking a picture to reduce vibrations and the risk of camera shake.

Model-release form

A legally binding form that models are asked to sign when they take part in a photoshoot. Gives the photographer the right to sell the pictures without the risk of any comeback.

Monochromatic

This means "one color" and is often used to describe black-and-white photography or color photography when an image comprises different shades of the same color.

Panning

A technique where the camera is moved during the exposure to keep the subject sharp but blurring the background.

Pinhole camera

A simple camera that uses a tiny pinhole to admit light to the film rather than a lens.

Predictive autofocusing

An autofocus mode found on some SLRs that predicts how fast the subject is moving and automatically adjusts focus so that when the exposure is made your subject will be sharp.

Primary colors

Those colors that form white when combined. Red, green, and blue are the three primary colors of light.

Prime lens

Any lens with a fixed focal length, such as 28mm, 50mm, or 300mm.

Rule of thirds

A compositional formula used to place the focal point of a shot a third into the frame for visual balance.

Softbox

An attachment that fits over a flashgun or studio flash unit to soften and spread the light for more attractive results.

Stop

The term used to describe one f/stop. If you "close down" a stop you select the next smallest aperture; if you "open-up" a stop you select the next largest aperture.

Vanishing point

The point at which converging lines in a picture—such as furrows in a ploughed field—appear to meet in the distance.

Vignetting

See Cut-off.

Index

Acknowledgments

All images are copyright of Lee Frost,

except for images on pages 88-95

(sourced from iStockphoto.com)